CW00549999

Delhi: Communities of Belonging

Delhi: **Communities of Belonging**

Sunil Gupta and Charan Singh

THE NEW PRESS

Requests for permission to reproduce selections from this book should be mailed to: Permissions Department, The New Press, 120 Wall Street, 31st floor, New York, NY 10005.

Published in the United States by The New Press, New York, 2016
Distributed by Perseus Distribution

ISBN 978-1-62097-265-6 (pbk)
ISBN 978-1-62097-266-3 (e-book)

The New Press publishes books that promote and enrich public discussion and understanding of the issues vital to our democracy and to a more equitable world. These books are made possible by the enthusiasm of our readers; the support of a committed group of donors, large and small; the collaboration of our many partners in the independent media and the not-for-profit sector; booksellers, who often hand-sell New Press books; librarians; and above all by our authors.

www.thenewpress.com

Book design and composition © 2016 by Emerson, Wajdowicz Studios (EWS)
This book was set in Avenir, Helvetica Inserat and News Gothic

Printed in the United States of America

10 9 8 7 6 5 4 3 2 1

Preface
JON STRYKER

The photographs in this book and others in this series are part of a larger collective body of commissioned work by some of the world's most gifted contemporary photo-journalists. The project was born out of conversations that I had with Jurek Wajdowicz. He is an accomplished art photographer and frequent collaborator of mine, and I am a lover of and collector of photography. I owe a great debt to Jurek and his design partner, Lisa LaRochelle, in bringing this book series to life.

Both Jurek and I have been extremely active in social justice causes—I as an activist and philanthropist and he as a creative collaborator with some of the household names in social change. Together we set out with an ambitious goal to explore and illuminate the most intimate and personal dimensions of self, still too often treated as taboo: gender identity and expression, and sexual orientation. These books continue to reveal the amazing multiplicity in these core aspects of our being, played out against a vast array of distinct and varied cultures and customs from around the world.

Photography is a powerful medium for communication that can transform our understanding and awareness of the world we live in. We believe the photographs in this series will forever alter our perceptions of the arbitrary boundaries that we draw between others and ourselves and, at the same time, delight us with the broad spectrum of possibility for how we live our lives and love one another.

We are honored to have Sunil Gupta and Charan Singh as a collaborators in *Delhi: Communities of Belonging*. They, and the other photographers in this ongoing series, are more than craftsmen: they are communicators, translators, and facilitators of the kind of exchange that we hope will eventually allow all the world's people to live in greater harmony. ▓

Jon Stryker, philanthropist, architect, and photography devotee, is the founder and board president of the Arcus Foundation, a global foundation promoting respect for diversity among peoples and in nature.

Foreword
GAUTAM BHAN

The photographs in this collection tell, as they must, a number of tales.

The first is of a city. New Delhi has changed remarkably—and yet not changed at all—since the first of these portraits was taken. One way to trace this arc of time is through more familiar, more public markers—in the usual ways we tell our histories. There is the victory in the Delhi High Court in 2009 against India's 1861 anti-sodomy law, the 2013 reversal of that victory in the Supreme Court, and the 2015 sliver of hope of another legal turn in the ongoing battle. Yet telling the story of sexuality in the city just through the law would be a mistake. What the law doesn't capture is precisely where art must tread.

How does one capture the slow transition from silence to the first utterances about sexuality to this current saturation of speech? How do we capture what the first Pride Parade in 2007, the emergence of queer groups and spaces in almost every corner of the city, and the growing footprint of queer lives in the mainstream media did to the everyday lives of queer people in the city? How do we celebrate the new, the bold, the visible, the spectacular, and identify the quieter, subtler continuities of prejudice, silence, and violence? How do we read what is happening within queer spaces just as critically as we protested what was being done to us?

A visible, queer community has emerged in Delhi over the past two decades. What was silent and private has emerged into the public sphere. Gupta's and Singh's work bears testimony to this.

The images are defiant. They want not just to assert but to prove presence. The subjects gaze directly at the camera, the city secondary to them, challenging the viewer. They are of their time. The 2000s were when a distinctive queer culture was making itself felt in the city. Books were written. New groups and organizations were formed of every kind. Queer people came out not just in their own intimate settings but also in the mainstream media. Art, culture, and the visual image were an important part of a queer movement that was making its politics more public and more direct.

That moment has also shifted. The photographs in this book were all taken after 2010. The portrait remains the basic form, yet it is transformed. These new portraits look inward. They allow reflection. The environs are homes or private gatherings—the public is not to be fought for as urgently, as strongly, as before. Those within the photographs look and are lost in themselves and each other—they rarely gaze at the camera. Each portrait allows both subject and viewer to

Gautam Bhan teaches urban politics, planning and development at the Indian Institute for Human Settlements, Bangalore. He has been an active part of urban social movements on sexuality as well as housing rights and currently advises and trains governmental agencies at local, state, and national levels on housing policy. He is the co-editor of *Because I Have a Voice: Queer Politics in India* and co-author of *Swept off the Map: Surviving Eviction and Resettlement in Delhi*. He is the Sexualities Series editor at Yoda Press. Gautam holds a PhD in City and Regional Planning from the University of California, Berkeley. His forthcoming book is titled *In the Public's Interest: Citizenship, Evictions and Inequality in Contemporary Delhi* (2016).

pause, to take stock, to feel the silences and textures of everyday queer life. This is intimacy, a world shaped by but always beyond the easy chronologies of public queer history.

Other stories then emerge in the spaces that have opened up. Sexual identity has always had an uncertain life in the city. Its terms—gay, lesbian, bisexual, transgender—have always only been embraced provisionally and uncertainly, or (at least in their English versions) never embraced at all. The lives we see in these photographs remain difficult to classify. They are more easily read through what writers on sexuality like Akshay Khanna have called sexualness, desire that flows through you but doesn't define you or your life in easily identifiable ways.

This makes us think about how to read sexual lives that don't fit easily recognizable forms of queerness, relationships, or kinship structures. In these photographs, we see a diversity of ways of figuring out how to live individual and communal queer lives. The photographers lay no judgment on them. In each image, there are a multitude of unspoken, unanswered questions—what is the available degree of choice for the person? Is there a presence of joy or violence just outside the frame? We will never fully know how any of these people got here. We know only the glimpses that are offered of a shared queerness as the lines fade between friends and lovers, the single and the coupled, the monogamous and the open, family and friends, public and private. Joy finds its way in, and yet there is always a sense of solitude and uncertainty. As queer people, as people who live in Delhi, there is an instant of recognition even if we don't have the language for what binds us to the image. As someone who is a subject of this camera's gaze, I find myself in each of these pages and not just my own.

The city's divisions also run through these images. The absences in the book are those that haunt the city itself: FTM trans lives, the relative absence of older queer people, the degrees of representation that mirror inequalities of access. Like all texts, what is left unsaid, what cannot be said, is as much part of the story that is being told.

Gupta and Singh have given us a remarkable, quiet, unsparing set of images. They are portraits of shifting queerness told by two artists who have paid attention, have listened, and watched for a long time. Read and seen together, these are an archive of the city and of the queer life within it, one that tells us more about sexuality than any formal history. ▓

Prologue
SUNIL GUPTA AND CHARAN SINGH

We decided to take on this project as we have been interested in documenting and representing the lives of queer people in India and in the West for some time. Indeed, for both of us this interest has informed our life's work.

We met in 2009 in Delhi at an all-day HIV/AIDS panchayat, a local community gathering. Many things were newly possible at the time. You could publically identify as gay and even as HIV-positive without being immediately charged under Section 377 or stigmatized and cast out of society. As we became romantically involved, it became inevitable that our personal lives would overlap with our professional lives.

Sunil had been based in London as a photographer but had just moved back to Delhi for the first time since he was a teenager. He had spent his formative years photo-documenting the gay liberation movements in Montreal and in New York in the 1970s before becoming involved in race and queer politics in London. Charan, in response to the HIV/AIDS crisis that was finally recognized as a local issue in India years after it was first diagnosed in Chennai in 1986, had co-founded a network of fellow queer men that became one of the first public health groups for working-class queer men in Delhi. He had also created a graphic novel/comic to raise HIV/AIDS awareness for the Indian government's National AIDS Control Organization (NACO).

Immediately our own relationship impressed upon us everything that was unique to being gay in India. The law did not recognize our relationship, although an arduous battle at the Delhi High Court was about to temporarily decriminalize our sex life a few months later. For a moment it seemed as though everything was better, but soon it became apparent that the issue of class hung over us. One of us came from a more privileged background and was therefore able to live independently, to be out, and to travel internationally. He worked for himself and was secure from homophobia in the workplace. The other still lived at home and had no access to any of the same privileges. Our situation was, in many respects, a reflection of the queer community in Delhi, which was almost completely divided by money. That world was divided by language, too: English was the modus operandi of the middle-class Indian gay male world, which felt entitled to dominate the city's queer diversity.

Yet queer people survive and build communities across all levels of society despite discrimination, and through this book, we would like to share these lives as best we can.

Introduction
SALEEM KIDWAI

Delhi—Oh, its unadorned beloveds
Wear turbans but their tresses are loose,
They openly kill with their pride
Though they drink liquor in secret.
Muslims have become sun-worshippers
Because of these sprightly Hindu boys.
I am desolate and intoxicated.
(Amir Khusro 1253–1325)

Research into the history and literature of Delhi and the Indian subcontinent has revealed that there was always a presence of same-sex love in the city. Beginning in the thirteenth century, as urbanization fostered a more open, more cosmopolitan culture in Delhi, accounts of the city frequently mentioned its boys. Ziauddin Barani, the most important chronicler of the Delhi sultanate at the time, wrote about the beautiful boys in the streets and taverns and the fascination of two successive sultans with their male lovers—one, a eunuch; both, commanders of the royal armies.

The Sufis, highly influential Muslim mystics, often focused on the love for a man or boy as a method of reaching their goal of divine love. One such Sufi was Sarmad, whose popularity with the people of Delhi led to his execution by the Mughal emperor Aurangzeb in 1660. Sarmad had come across a boy, Abhai Chand, who was singing a *ghazal*, and was instantly attracted to him. According to the saint's "official" biography, "For some days the attraction continued from afar. Eventually the sparks of the fire were fanned by the flames of love and it began to blaze, and Abhai Chand began staying with Sarmad." Sarmad is today called the "Colorful Saint" and his shrine at the foot of Jama Masjid mosque in Old Delhi remains a popular pilgrim site in the capital.

Old Delhi is the former Mughal capital of Shahjahanabad, where a new language, Urdu, developed that became a vehicle for the expression of homoerotic love. The Urdu poet Najmuddin Mubarak Abru (d. 1733), who once wrote, "He who chooses a whore over a boy/ Is no lover but a creature of lust," led the way for other homoerotically inclined poets. Abru was romantically involved with another male poet, and many of his couplets refer to his interactions with men as he strolled through the gardens, streets, and alleyways of Delhi. Another Urdu poet, Taban (d. 1750), praised by all his contemporaries for his magnificent appearance, mentions his lover Sulaiman in his couplets, and it has been suggested that Taban too was the lover of an older poet.

Saleem Kidwai studied history at the University of Delhi and at McGill University. He taught medieval Indian history at the University of Delhi for twenty years. Since 1993 he has been an independent researcher and writer. He is the co-editor (along with Ruth Vanita) of *Same-Sex Love in India: Readings from Literature and History*. He has also edited and translated *Song Sung True*, the one-of-a-kind autobiography of Malika Pukhraj, a leading courtesan singer of the twentieth century. He has translated several works from Urdu into English as well as written many articles for leading publications. He lives in Lucknow, India.

Quli Khan, a visitor to Delhi from South India, gives a graphic account of the city in the mid-eighteenth century. In the crowded bazaars, "good-looking young men danced everywhere creating great excitement." Aristocrats had harems of young men, musical soirees teemed with male moon-faced beauties, and eunuchs were highly sought after. Mir Taqi Mir (d. 1810), considered by many to be the greatest Urdu poet, bemoaned the city's temptations:

The boys of Delhi with their caps askew
Were the nemesis of lovers,
No lovers are now visible –
The ones wearing caps have carried out a massacre.

After the British suppressed the first Indian war of independence, also known as the 1857 Mutiny, the Crown took over the East India Company's Indian territories, including Delhi, and in 1860, this enabled the British to pass the anti-sodomy act in India, which became Section 377 of the Indian Penal Code in 1861. Under this section, any act of "carnal intercourse against the order of nature with any man, woman, or animal" is punishable with imprisonment from ten years to life. Historically this has led to only a handful of convictions, but its mere existence has been used as a tool to harass and blackmail homosexual men ever since it came into being.

The British government, now ruling directly, began imposing Victorian Christian values, aggressively attacking local social and moral values and condemning Indian rulers and people as licentious, debauched, and primitive. Indian intellectuals and reformers followed suit, and Urdu critics condemned expressions of same-sex love, sometimes resulting in their expurgation or bowdlerization. Public expressions of same-sex attraction were taboo, and gay men kept their desires to themselves or to a small network of friends. As a result, our information for the first three decades of the twentieth century is mainly anecdotal and at best based on snippets from memoirs.

For example, Urdu poet Akhtar ul Iman, who went to a boarding school in Daryaganj, Old Delhi, in the early 1930s, recounts how the father of one of his classmates turned up at school to beat his son, who had been staying away from home and spending nights with his lover. Another classmate was seeing a one-armed lover who was a snake-catcher and would wait for the boy outside school every day. Iman discouraged the boy from carrying on the liaison and was attacked and spat on by the snake-catcher for his pains.

With the completion in 1933 of Connaught Place, the colonnaded central shopping district in colonial New Delhi, its central park developed into a cruising area frequented initially by British colonial employees seeking contact with locals. During the war years, the induction of British troops and more British civil servants made the park increasingly popular. In the 1970s, the expansion of Delhi created yet another major cruising area in Nehru Park.

Gay men also met through widening personal networks, with small groups meeting in private homes. These networks continued to expand until the 1980s, when homosexuality suddenly became more visible with the devastating onset of AIDS. During that time, often short-lived gay organizations met in coffee houses and public parks. Groups that had been purely social began to politicize. Gay male AIDS activists from other cities met on the fringes of larger HIV/ AIDS conferences. Non-resident Indian artists like Sunil Gupta and Pratibha Parmar created works of art that touched on queer issues. The circulation of *Trikone,* a U.S.-based newsletter for LGBTQ South Asians, helped queer Indians to network. Journalist Ashok Row Kavi, who later founded *Bombay Dost,* outed himself on the cover of a feminist magazine, *Savvy* (1986).

The lesbian group Sakhi was founded in Delhi in 1991. The same year, AIDS Bhedbhav Virodhi Andolan (ABVA, or the AIDS Anti-Discrimination Campaign) published *Less than Gay: A Citizen's Report on the Status of Homosexuality in India,* in which it demanded, among other things, the repeal of Section 377. In 1992, ABVA put forward an unsuccessful petition in parliament supporting this repeal. In the same year, the first public demonstration took place outside police headquarters in Delhi, protesting the harassment and arrest of suspected gay men in Connaught Place Park.

In January 1993, the group Friends of Siddhartha Gautam organized a film festival on AIDS and sexuality at Max Mueller Bhawan to commemorate the late activist's death in 1992. Gautam was a member of ABVA and among those who drafted *Less than Gay.* The event, held annually for a few years, began attracting a few hundred LGBTQ people, and it was here that the first formal gay male organization, Humrahi, was formed. Supported by the Naz Foundation, Humrahi lasted much longer than earlier groups. Meanwhile, Naz, which ran an HIV/AIDS clinic, condom distribution programs, support groups for gay men, and eventually a care home for children with HIV, created a separate space for Hindi-speaking *kothis* (effeminate male sex workers who usually live in the slums and are married), and other vulnerable working-class men called *milan*.

This was the beginning of an Indian gay political culture. Queer Delhi men are now ready to step out of their closets and demand a change in the law. ▦

On July 2, 2009, the High Court of Delhi, ruling on an eight-year-old petition, declared that Section 377 of the Indian Penal Code, which criminalized consensual sexual acts between adults, was a violation of the spirit of the Indian Constitution. This relief from a 150-year-old colonial law was, however, short-lived. Several religious groups appealed to the ruling, and on December 11, 2013, the Supreme Court of India overturned the High Court's decision.

Several LGBTQ and human rights groups asked the Supreme Court to reconsider its ruling. On February 6, 2016, a three-judge bench of the Court said that a Constitutional Bench of the Court would reconsider the plea. That is where matters stand today, with the lives of the Indian LGBTQ community still in limbo.

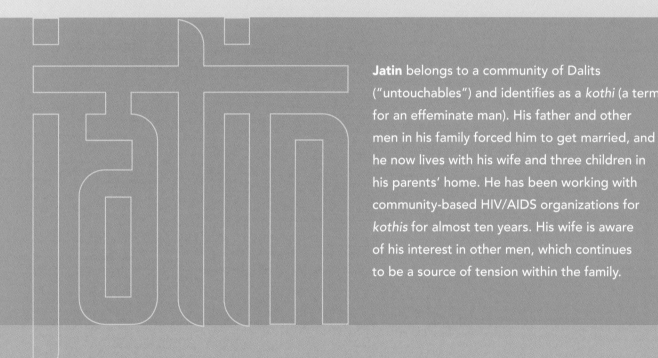

Jatin belongs to a community of Dalits ("untouchables") and identifies as a *kothi* (a term for an effeminate man). His father and other men in his family forced him to get married, and he now lives with his wife and three children in his parents' home. He has been working with community-based HIV/AIDS organizations for *kothis* for almost ten years. His wife is aware of his interest in other men, which continues to be a source of tension within the family.

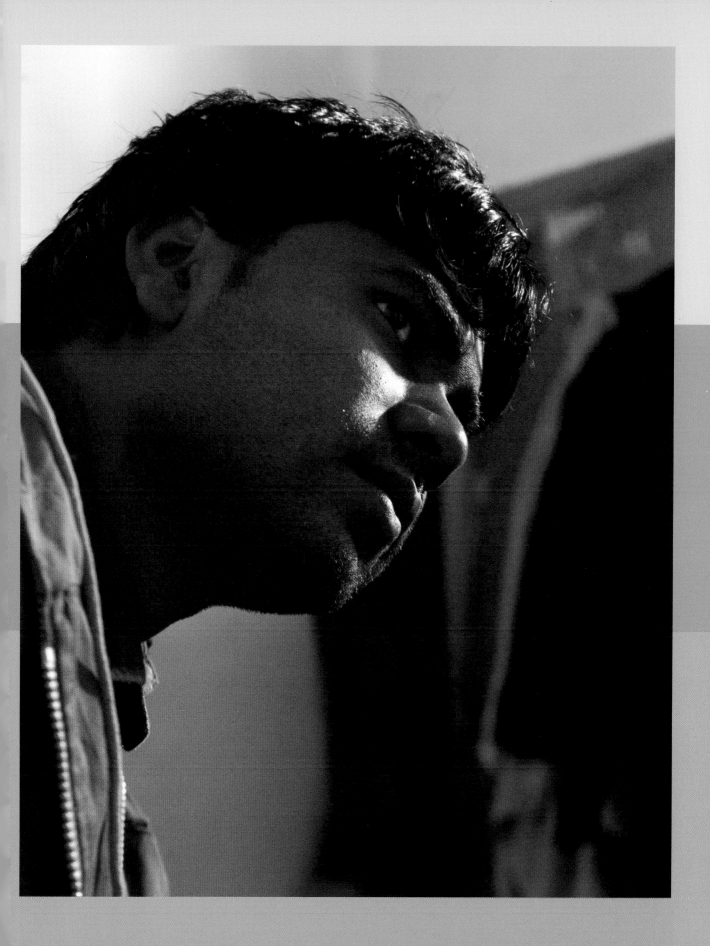

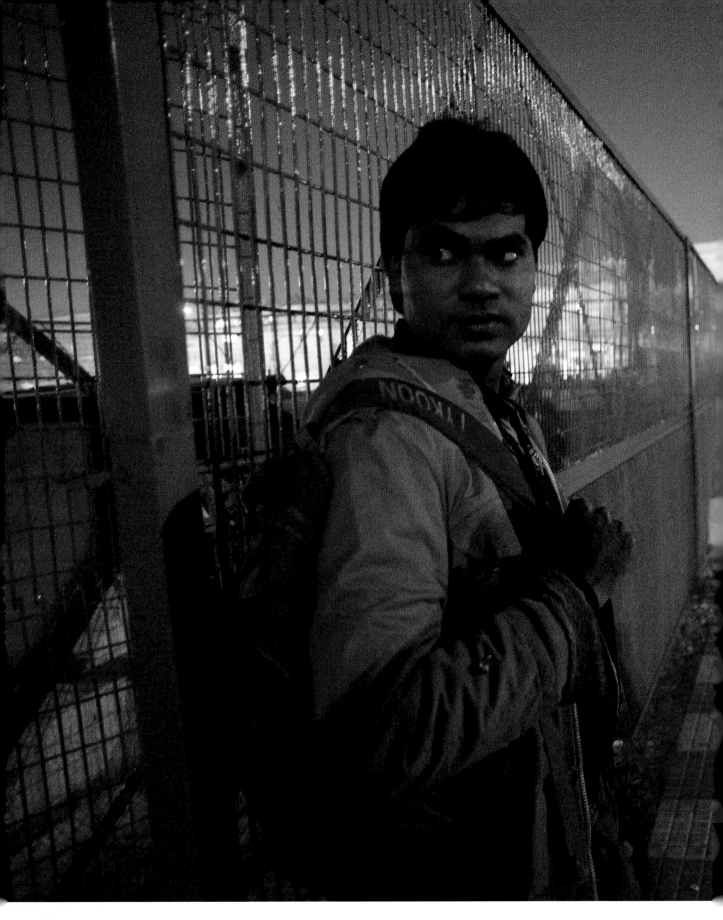

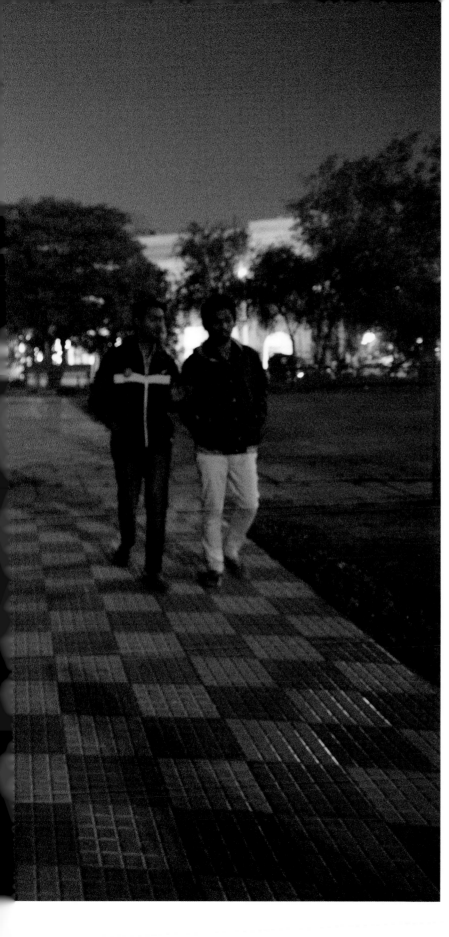

I come here to Connaught Place to seek out sexual partners on my way home. I work nearby so it's easy for me to visit. I don't want to disclose my identity in my neighborhood, which is a bit unsafe and rough. So in Connaught Place I can meet people like me and share my feelings, my happiness and my sorrows, with them. I can find boyfriends here to have sex with, and sometimes they take me to their homes. »

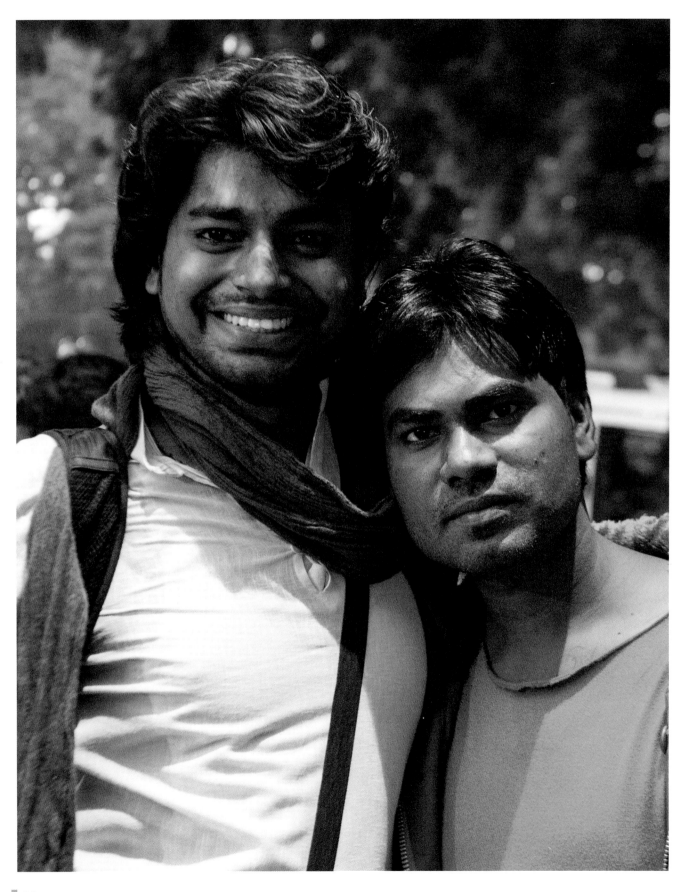

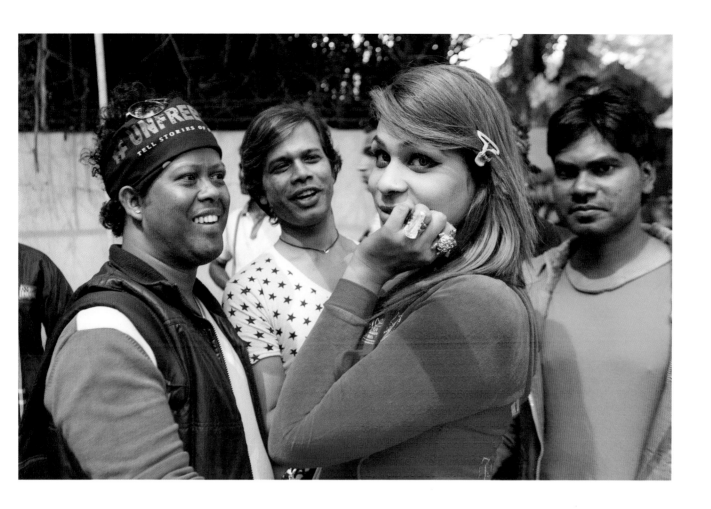

I studied in a government school where the older boys used to force me to masturbate them. It was all forced upon me. But as time went by, people started teasing me for it. Some used to call me names. I used to feel bad. There was a lot of shame. I used to think that I was the only one like this. Once I attempted suicide. I was tired of the taunts at home, from society, and in school from my peers.

By fourteen, I developed a great interest in boys. I started enjoying sex with some of them. Slowly that network grew and I came to know many boys like me. Once I met a boy who told me that you could get money for having sex with men. He took me to the interstate bus terminal, where I saw there was a public toilet where many people came and went and some just hovered. The next time I went in and stood at the urinal, seeking people for sex. I started having a lot of sex. I was getting money for it. I started going there almost every day. »

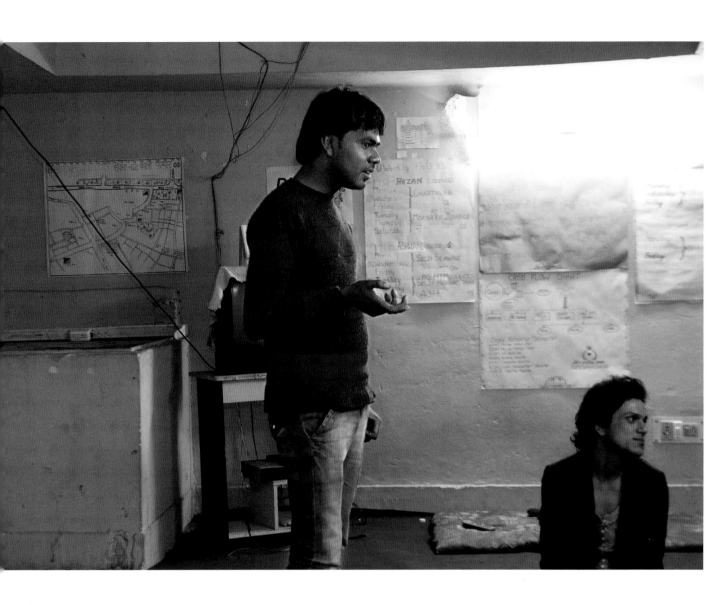

Workers from an organization called DART came to distribute condoms, and hand out information about STIs and HIV. They invited me to come to their drop-in center. When I went there I saw many people like me, many effeminate men and transgender people. They were having a fun time. I thought I should get involved with them. It's been many years now. I am working with them to help people like me. »

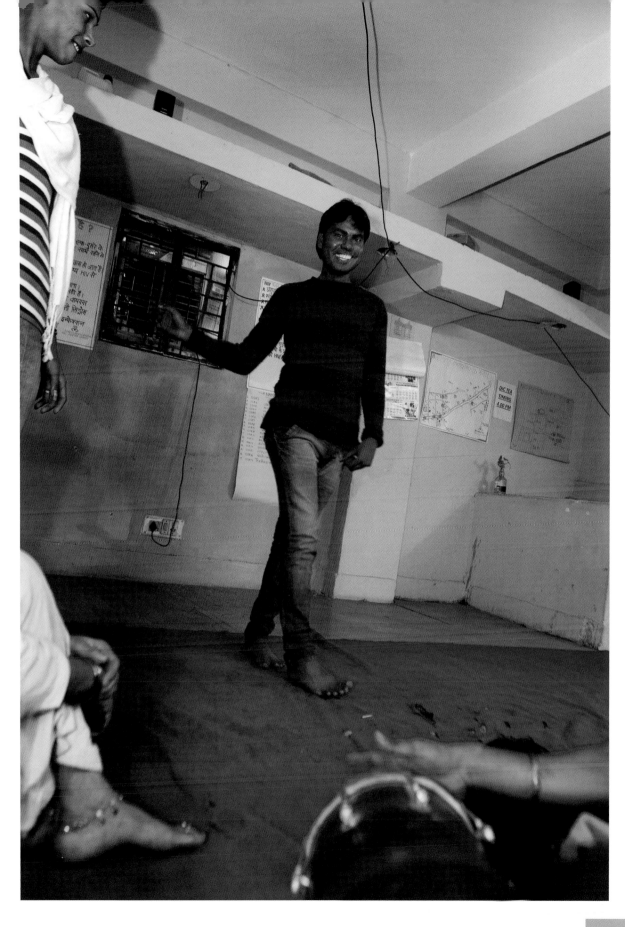

I got married in 2007. It was a forced marriage. My family knew that I was feminine. Once I overheard my parents talking about me, saying that I am very feminine but that after marriage I will be fine. Now I have two daughters and one son. It's a difficult situation. I feel stuck with my marriage, but I do feel that I must sacrifice my desires and protect my family. I should change. There is no other way. That is my responsibility. »

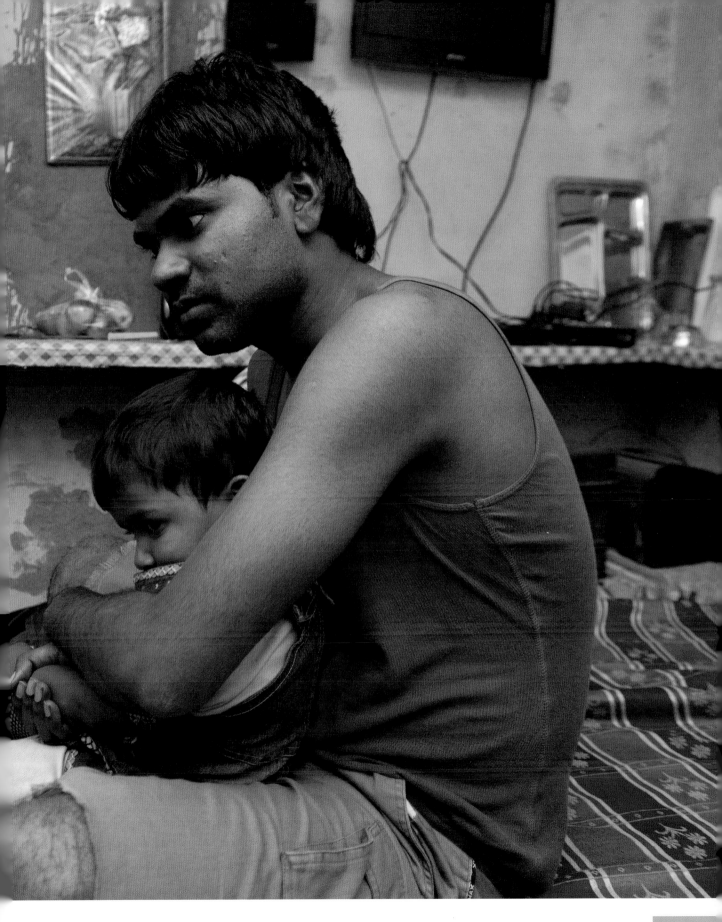

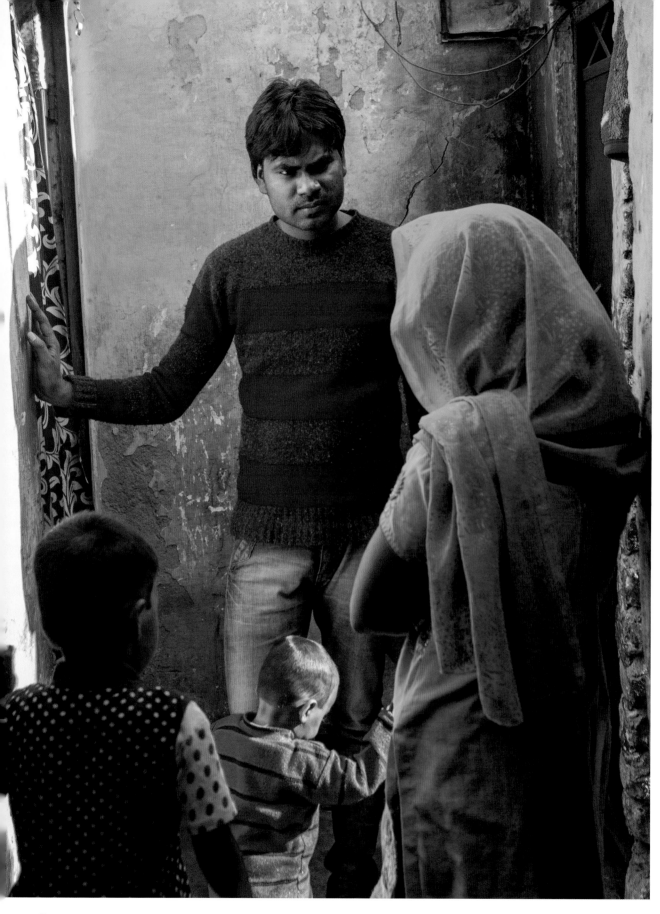

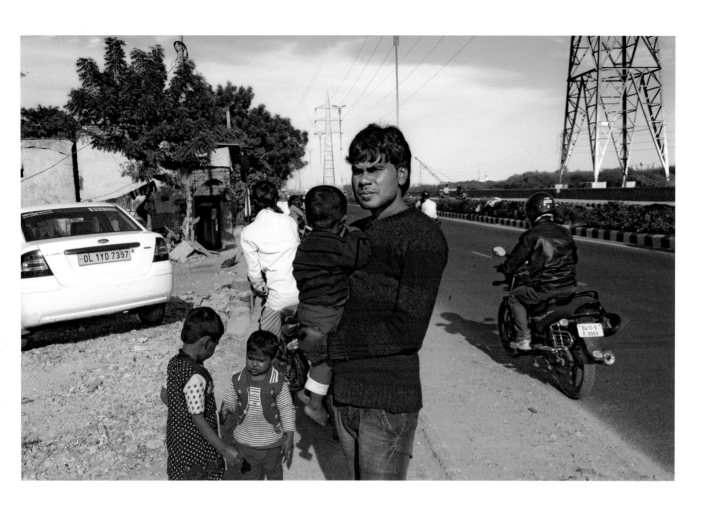

However, if at the time the law had allowed it, I could have told my parents that I wanted to marry a man. I would have been able to get some help. I would have taken them to someone who can make them understand, an advocate or a counselor. Between 2009 and 2013, there were many of us coming out to our families and society. We were beginning to lead our lives the way we wanted. But now we are back where we were. Now we fear the law and the police again because now everybody knows what Section 377 is and how it implicates us and on whom it casts suspicion.

Bringing back 377 is wrong. If we are over eighteen years old and we can make our own decisions, then we should also have the right to choose our own partner. ▪

Krishan

Krishan was born and grew up in Delhi. His family is from Rajasthan, but he feels little connection to his heritage. He did not study beyond eighth grade in school and worked all his life as a mason until he was diagnosed with HIV a year ago. He is married and lives with his wife and ten-year-old daughter near his parents' home in a small house they gave him.

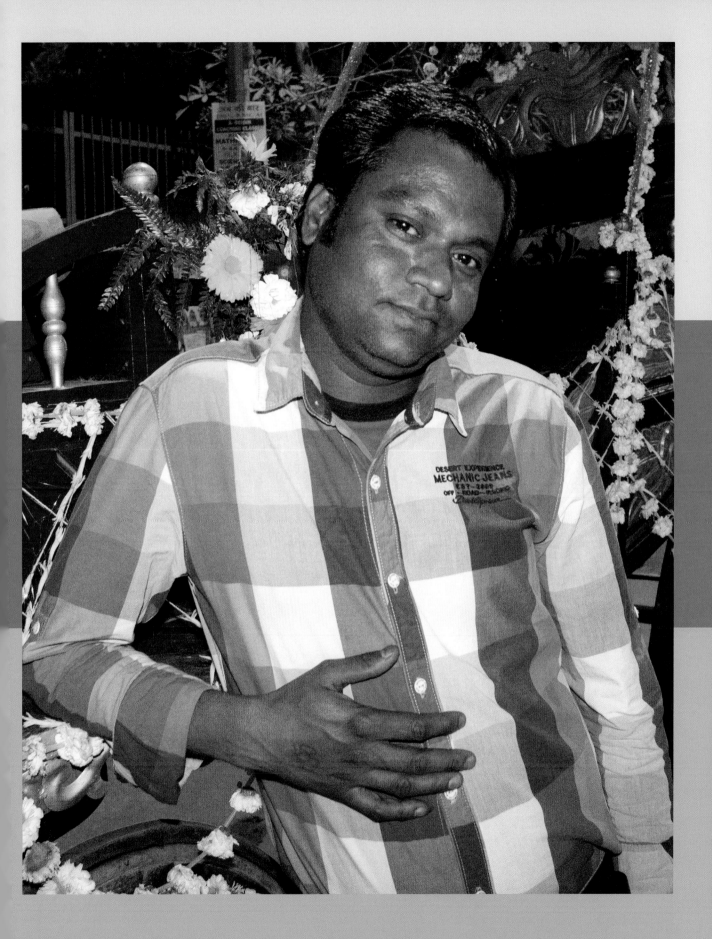

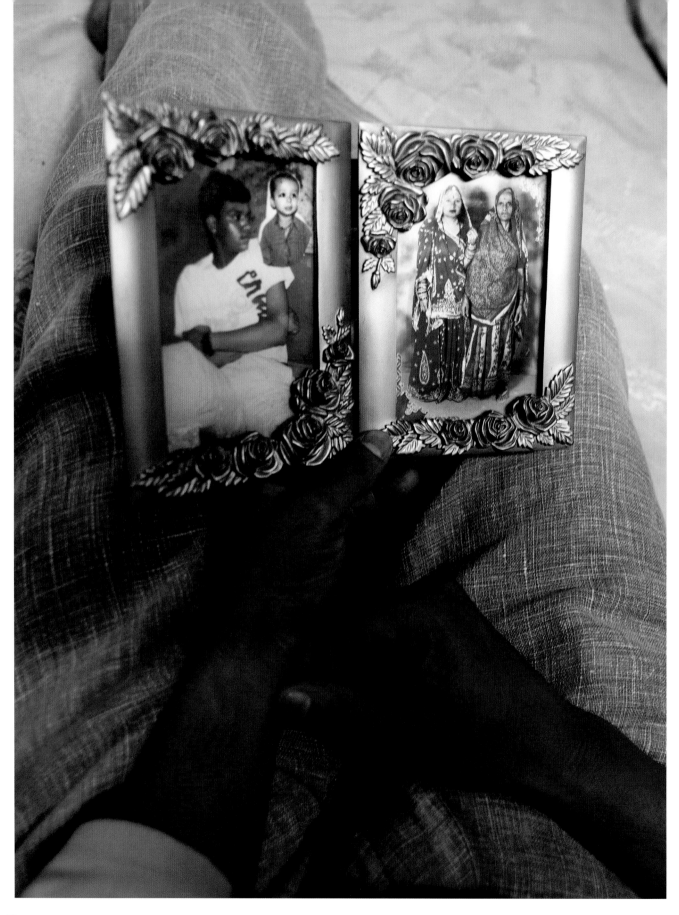

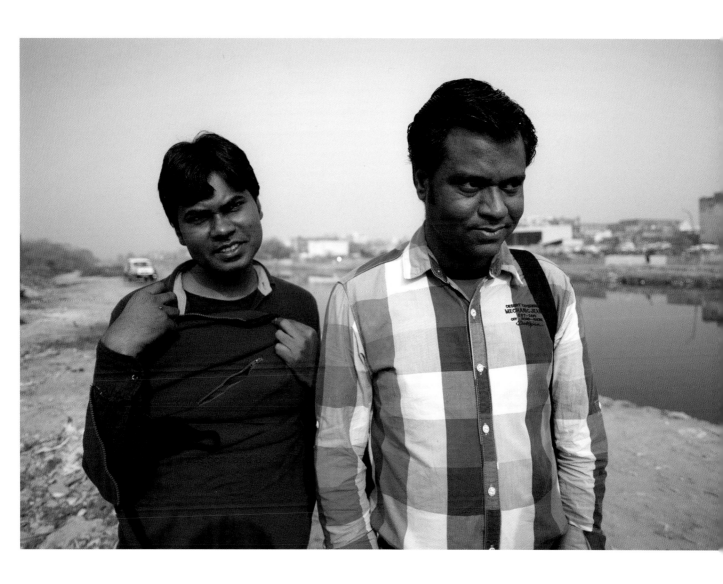

I was born and bred in Delhi. I live with my wife and a daughter. I live in a house owned by my family. My parents also live in the neighborhood. I studied only till eighth grade. My school was very close to my home so I never went far from home. I was an eight-year-old boy when I had my first sexual experience. It started with humping and slowly it turned into "actual" sexual encounters. I liked it. »

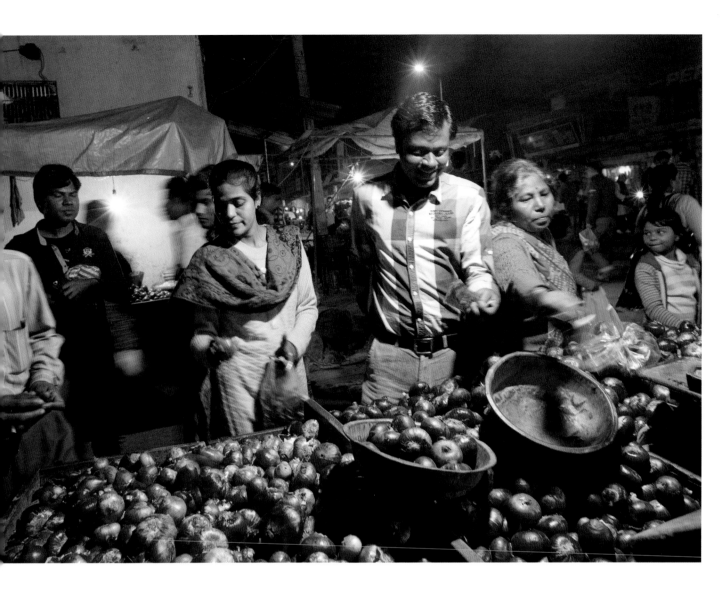

It all started with one boy at a wedding. We stayed together that night, but he told other boys, and soon many other boys got to know that I had sex with him. Later I ended up having sex with all of these boys from my colony [the official term for specific residential neighborhoods in Delhi]. As a child, I did not have any feminine habits, no effeminate behavior. But I liked to have sex with boys. Later when I was fourteen, I learned about cruising places just across from our colony where people used to go to the toilet. Policemen used to come, but since I am straight-acting, they never harassed me. Nobody figured out what I was, unless I said so. One day, the police raided it as they do, every now and then. People were running here and there. A policeman started telling me that sex between men is criminal under the law. One of my friends who was there with me responded, "How would I know? I'm just having a little fun. I never knew that the government had placed a ban on that too." The policeman was stunned. Then he left.

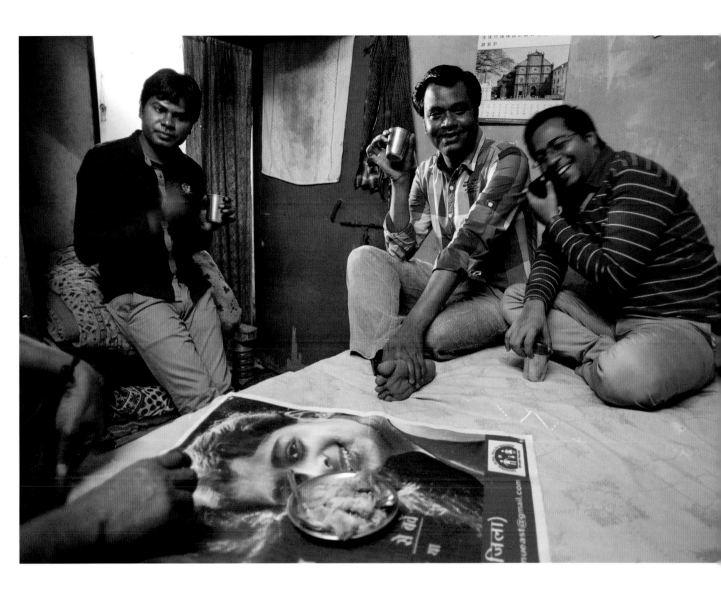

I was around twenty-five years old when I got married. I think I just gave in too quickly. Now I feel that I should not have gotten married as I am more sexually inclined towards men. However, I was under pressure to marry and produce kids, then more pressure to have more kids.

Ultimately I had to confront my family. I have HIV. I don't want to risk my wife's life. It's been a year since I was diagnosed. When I tested positive for HIV, I told my wife. We both hugged each other and cried for a while. I got her tested, too. She is fine. My child is okay, too. I have only one daughter. She's ten. The thing is, I never used condoms before. I never knew about condoms. It's only now I got to know about them. Now whatever I do, I keep condoms with me 24/7 in my pocket. ››

I never had any difficulty having sex with women, but I like it more with men. Lately I feel like I don't like sex with women at all. But I have to have sex with my wife. That's my duty. I always use a condom with her.

I can have sex actively or passively, and if someone gives me money, I'll take it. Ever since I got involved with NGOs, I can say that I am "gay." Before that, I didn't know [what to call myself]. ▪

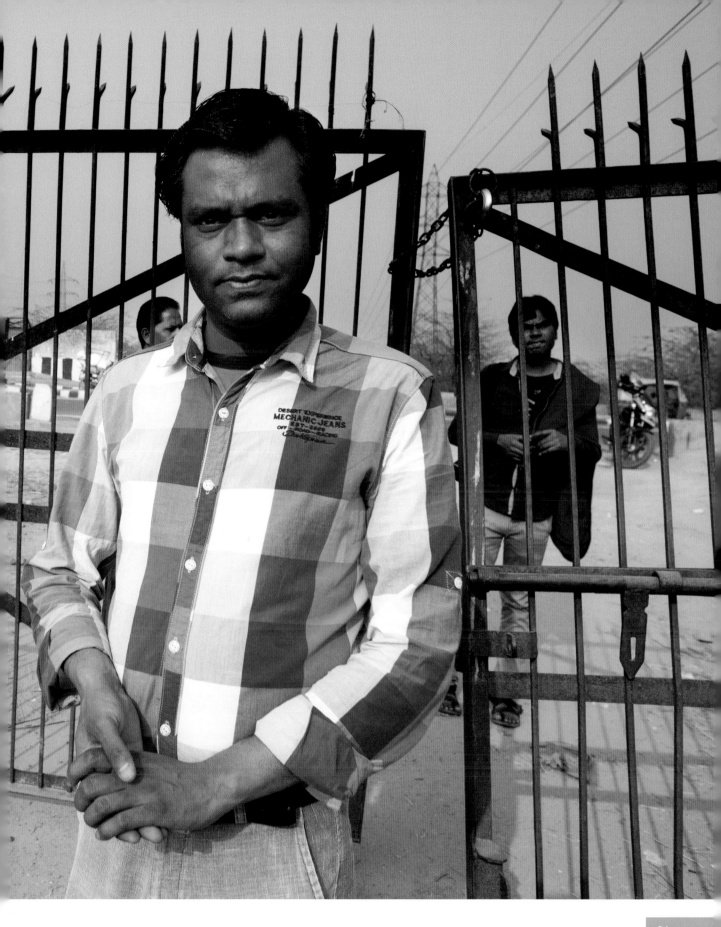

rizwan

Rizwan migrated to Delhi from Nazibabad, a small town in Uttar Pradesh. He is a practicing Muslim and lives with his mother, his brother, sister-in-law, and their children. When he was eight, he was suspended from his religious school because he was considered too feminine and therefore a bad influence on the other students. Now he works with a community center for HIV awareness in an industrial district on the outskirts of Delhi. He is learning to read and write.

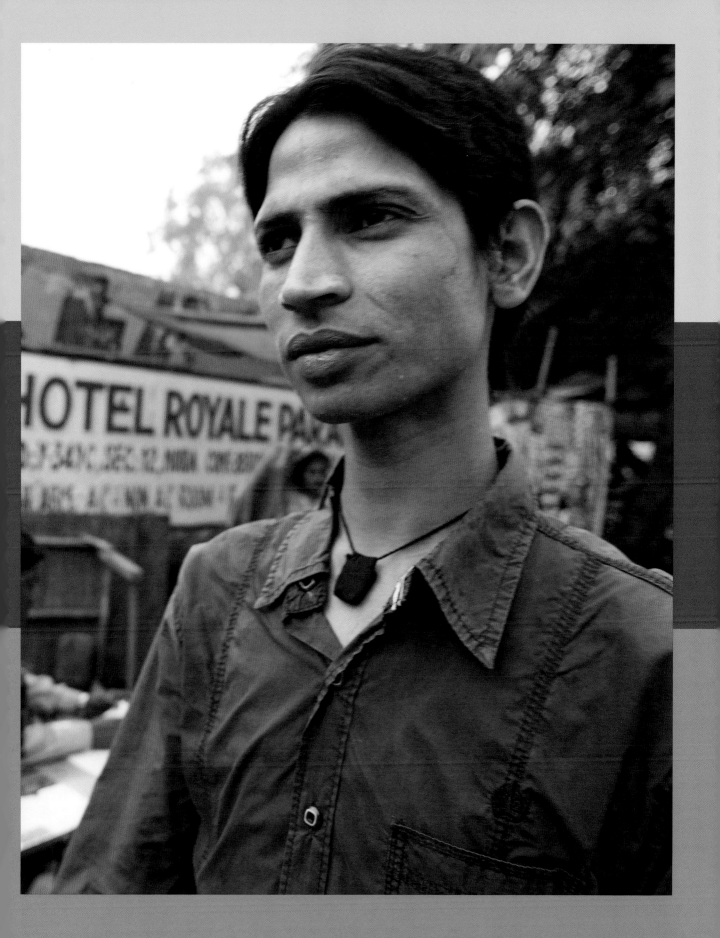

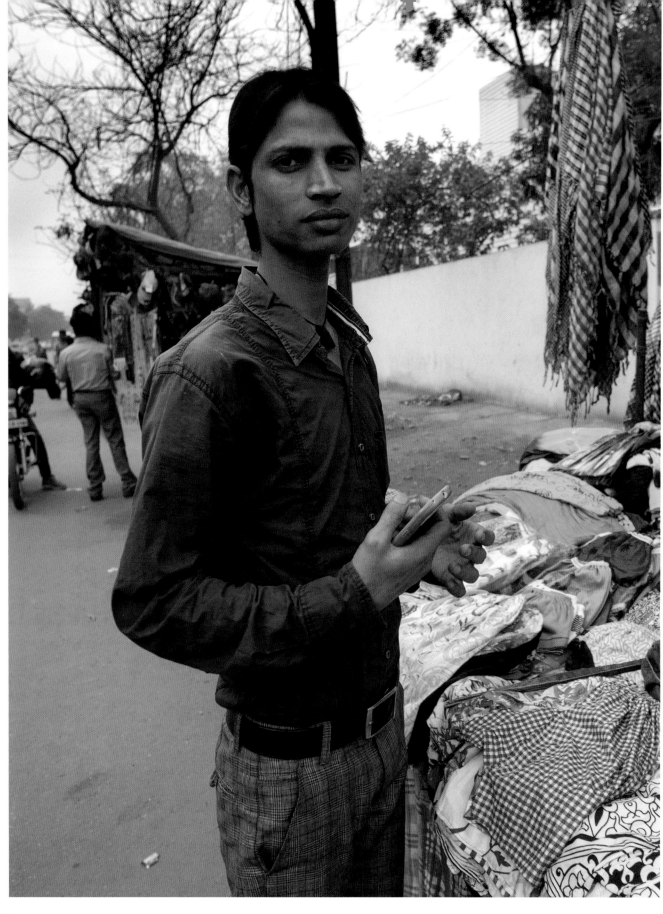

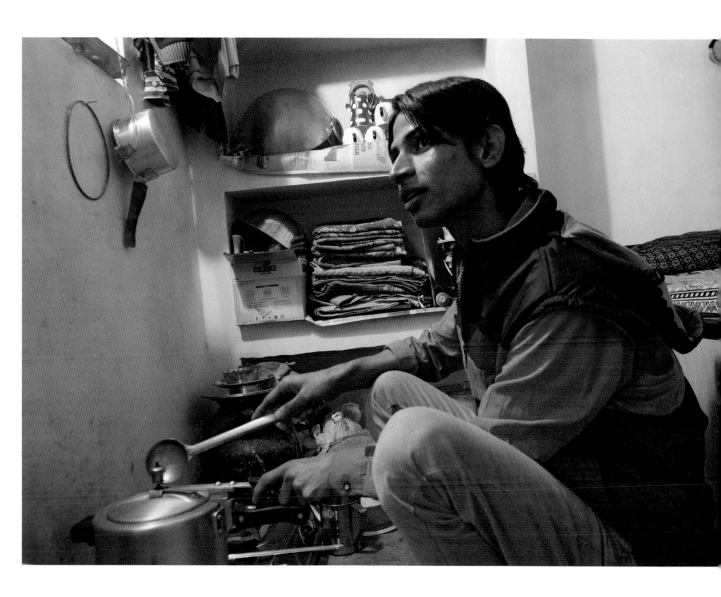

I used to study at a *madrasa* [an Islamic religious school] as a seven-year-old. I had a habit of wearing my sister's clothes or sometimes I used to wear my mother's sandals. I used to love dressing up. This became a huge issue. They asked me to leave the *madrasa.*

My parents didn't think too much of it, but they sent me to my sister's home. She was married and lived in a village close by. I lived with my sister for five years. Later my sister faced issues because of me. Things got worse and my sister got threatened with divorce if she would not send me back.

There were already issues regarding my staying on in the village so when I was sent back to my parents they decided to move to Delhi. I was thirteen by then. I had never gone back to school. I just spent my time at home helping my mother in her domestic chores, preparing meals for my brother and father. That was my life for the next few years. »

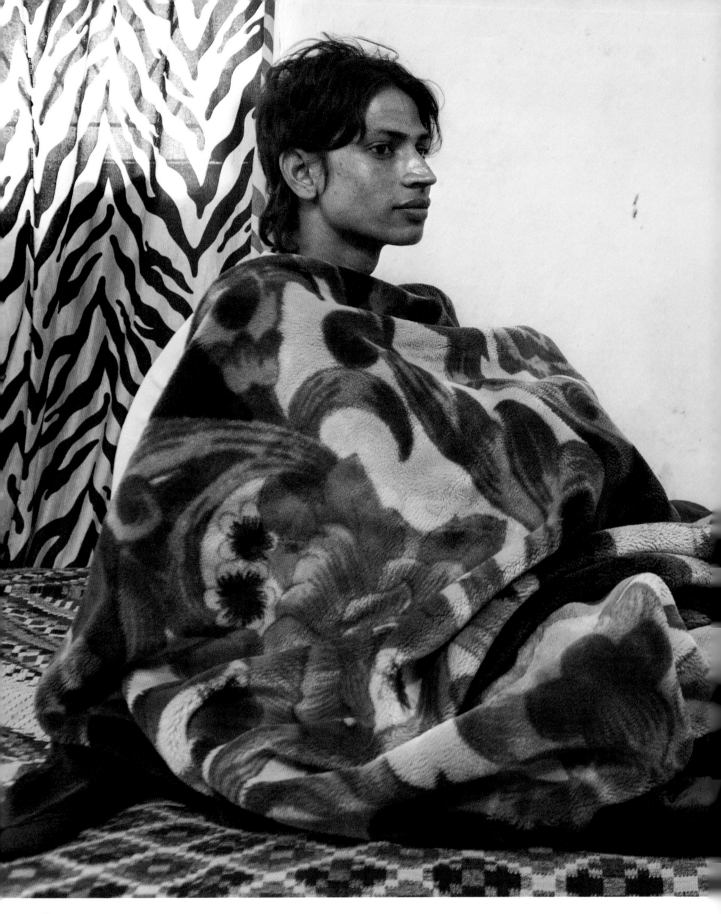

One of my first friends came along, a *kothi* [working-class effeminate man] who was a lot older than me. I discovered that there were people who were like me. At the time I had not thought about sex but, yes, my attraction was toward boys. He took me to places where people meet for sex. My first sexual encounter was with my landlord's son, when I was seventeen. That's the moment I realized that I have homosexual feelings. At the same time, I felt awkward. I was wondering, "Why am I different from my brothers? My mother treats me as a boy but why do I feel like a girl? Why do I like to dress up like a girl?" Slowly I felt distanced from my family and later I joined the *hijra* [trans women] community for three years in Kanpur, Uttar Pradesh. But in my opinion, that life was not for me. »

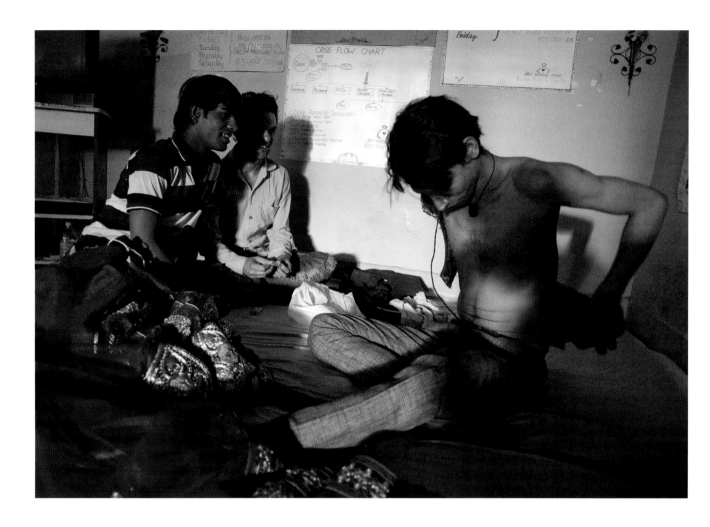

I have met some friends, with whom I have started sex work. Initially I was going in boy clothes, but slowly I started dressing up, which had more benefits, including many clients who thought that I was a woman at first sight. They paid us more when we cross-dressed. That's where I met health workers from a community-based organization (CBO) and I learned about safer sex practices and started going to their community centers.

Now I work with one of the organizations that work with MSM (men who have sex with men) and transgender people. I can fulfill my desire to wear a sari and make-up, and dance. I still do sex work. Sometimes for money, sometimes for fun.

When I came back to my family house, they accepted me, although I cannot cross-dress here. I do not discuss my sexuality with them. The only regret I have is that I could not study like other children and have a career. However, now I work for people like me and I am happy. I have started private coaching to learn Hindi and English. ■

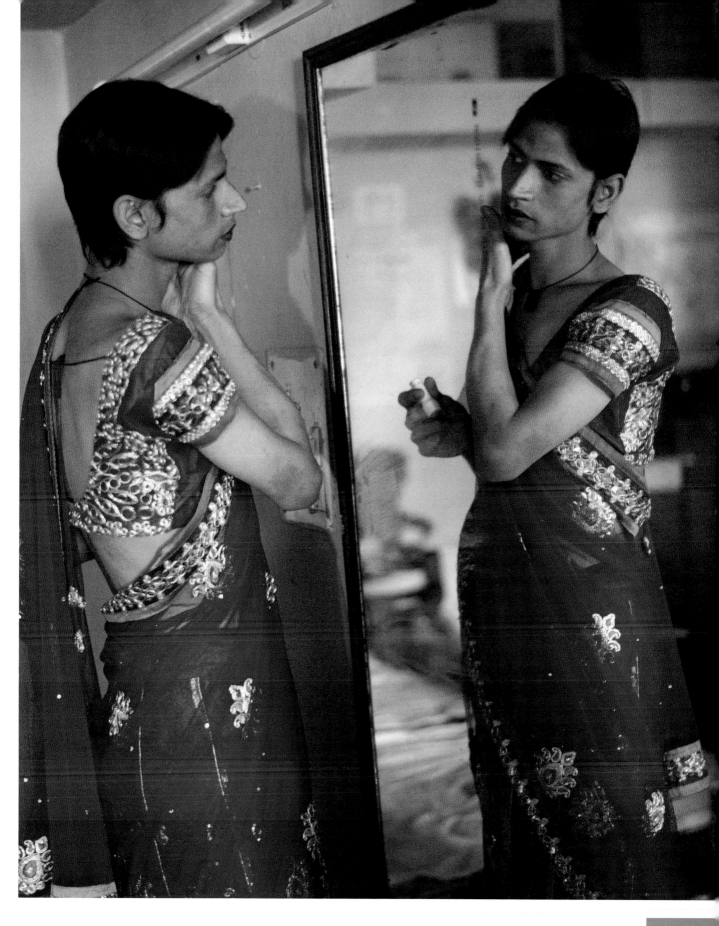

Rituparna is a queer woman who hails from northeastern India. She had her first sexual relationship with a woman as an undergraduate at the University of New Delhi, although due to her sheltered upbringing, she had no name for what she was experiencing at the time. At first she decided to keep it a secret, but anger over the anti-sodomy law led her to become an activist. Now she is a spokesperson for the queer community. As a result, her family has found out about her sexuality. Rituparna has since managed to reconcile her family to her new life and partner and is working to start a new NGO focused on queer women in Delhi.

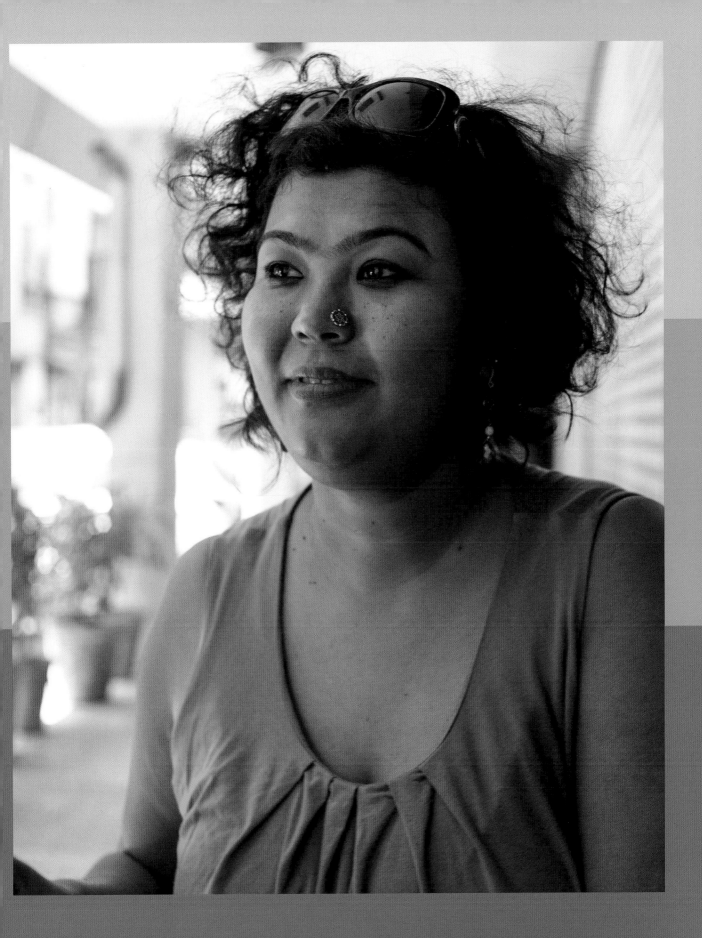

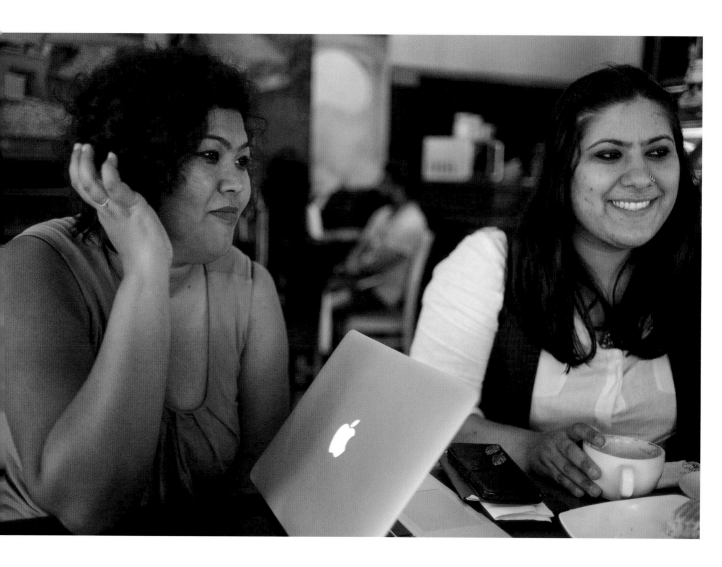

I was born in a small village in Assam. In 1999 I came to Delhi University, then stayed for my postgraduate studies. Half of my life has been in Delhi now. I belong to a tribal community, but my mother and father were both professors. Because of them I was encouraged to study. The first time I heard the word "lesbo" was when I came to college.

Nothing happened in college, just some erotic friendships. I was a tomboy at that time. I used to dress up like a boy. I was tall and people mistook me for a boy. Suddenly one day I realized that I wanted to look feminine. At that time, I fell in love with a woman. I didn't have the courage to say anything. I was damn scared because the woman I loved so much had boyfriends. Those were

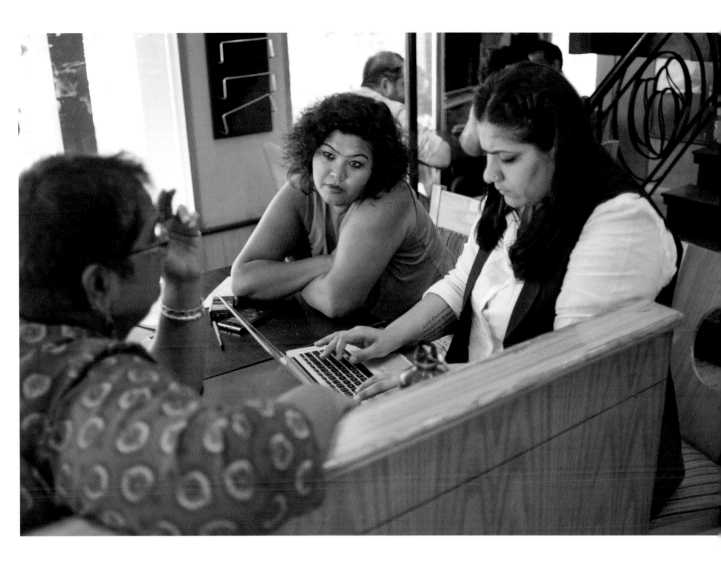

lonely nights, when she would go out with her boyfriends and I would sit and cry and feel, "Why am I not able to tell her?"

I didn't seek help either, even though I was going through a severe depression at that time. Three years went into loving her. I was completely isolated, I didn't want to be identified with an LGBT group and become stigmatized by the Assamese community. The psychiatrist that I was sent to was a great help. He gave me medicines, and I could finish my MPhil and I could be comfortable with myself. And then I joined an NGO because I knew there was a lesbian working there and I would be comfortable. Once I decided to come out in 2007, there was no looking back. »

It took me one year of activism to talk about my queerness. At the 2008 Pride I was carrying a banner and planning to hide my face, but my parents saw me on TV. Slowly I began talking to my parents, too. Being seen on TV was a big thing. Some friends left me. In 2009 when the judgment came, I came out on TV. My mother called up and said she saw something on the TV and "the whole colony is talking about it." She asked if I was one of them and I said yes. She hung up then and didn't call for a long time.

When the second judgment happened, I spoke to the media, I came home really late and the neighbors know about us, so I was thinking, "What will they think about us?" But nothing changed. My partner's office changed a lot. Every day she endured harassment, and every time they would quote the judgment, "See now you are bad." So she had to leave her job. Because of her being gender queer, she's more vulnerable than me, as I can pass for straight. Now she has a new job where she can't come out. She's scared now. But we also have good times. When I was in the hospital she got the right to visit me. »

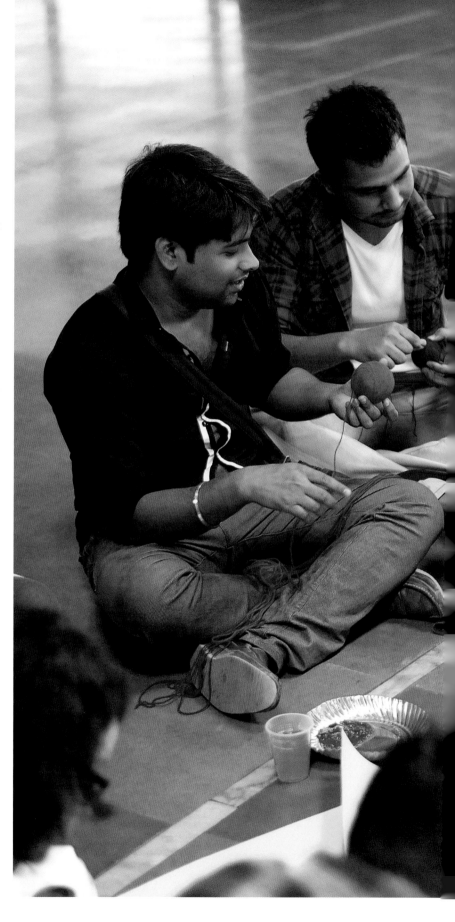

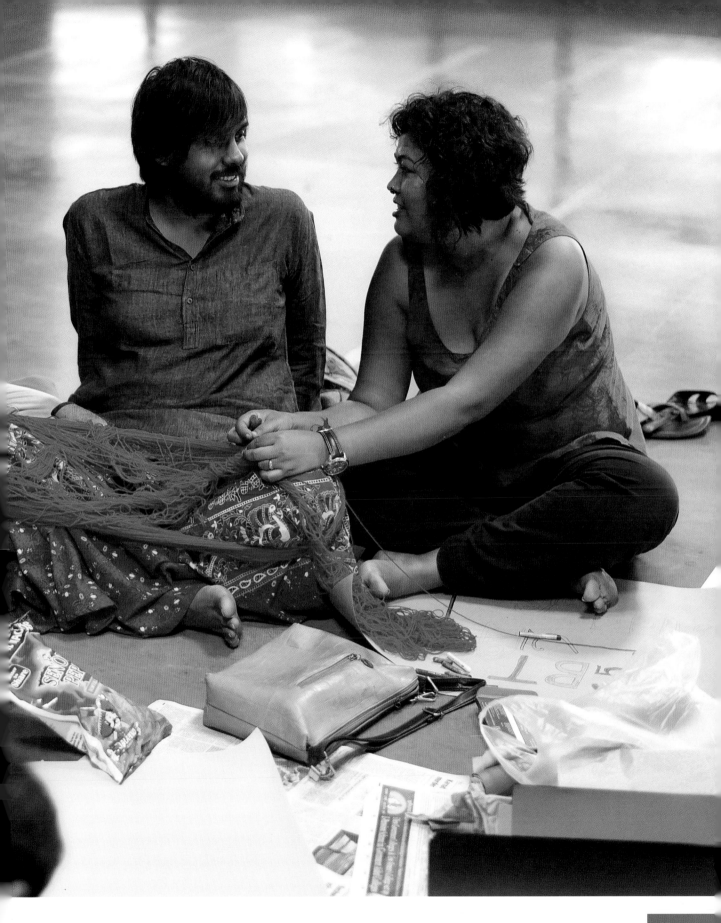

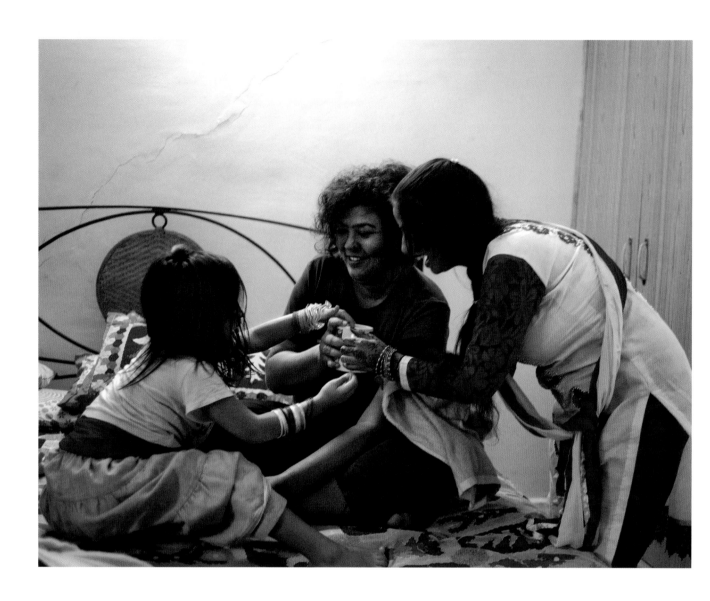

We were trying to adopt a baby. The adoption laws are so strict, and same-sex couples can't adopt. Both of us bought a flat together, but it's in my name, and she's my tenant. If I die, then she will get thrown out of the house. My parents are furious that she comes before them. I'm anxious about my will being contested. They complain about her all the time. My pension, insurance, it's all for my parents. I can't do it for my partner.

I also feel that there is less lesbian and women's presence in society. Therefore I go to speak in public. We are starting a group for LBTs [people who were gender identified as female at birth]. We are not sure how the government will react. ■

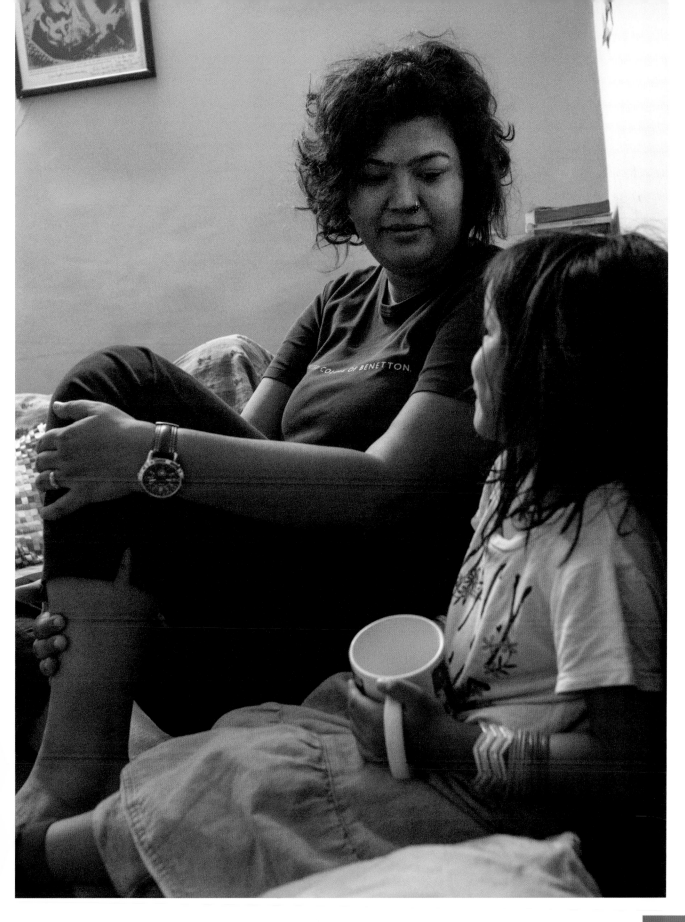

gautam

Gautam is Kashmiri but grew up in Delhi. He went to college in the United States, and since finishing his graduate degree, has returned to India, where he helped set up the Indian Institute of Human Settlements in Bangalore and is a professor of urban studies in Delhi. Even while he was in the United States, he has been at the forefront of the queer movement in India, and he is the co-editor of the anthology *Because I Have a Voice*. In Delhi, he shares his home not with his partner, Rahul, but with a close friend, Pavitr, reflecting a trend to leave home in search of queer alternatives to traditional family structures.

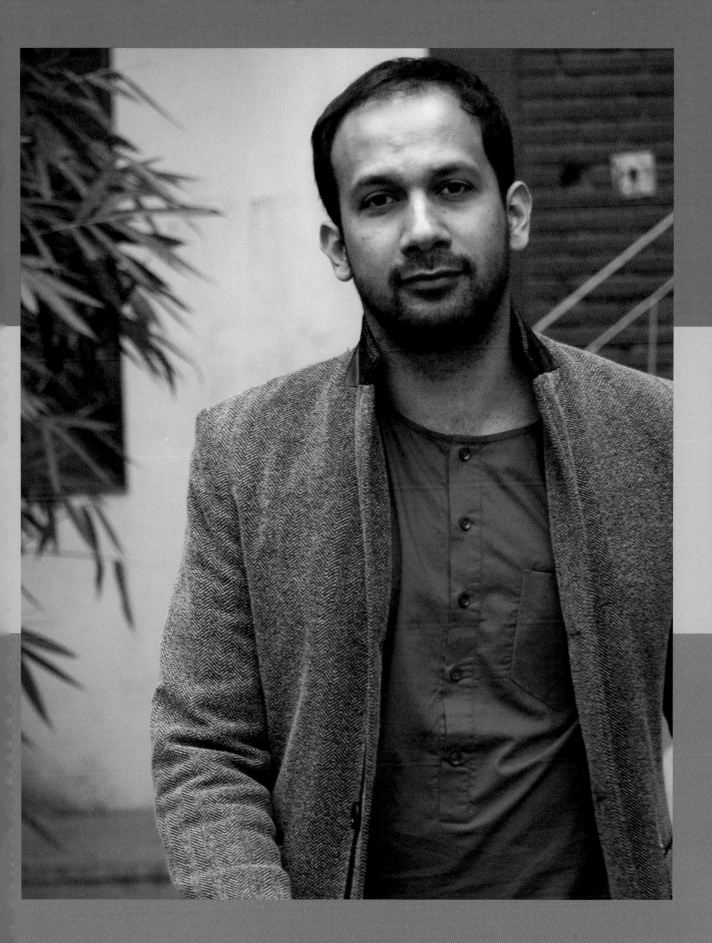

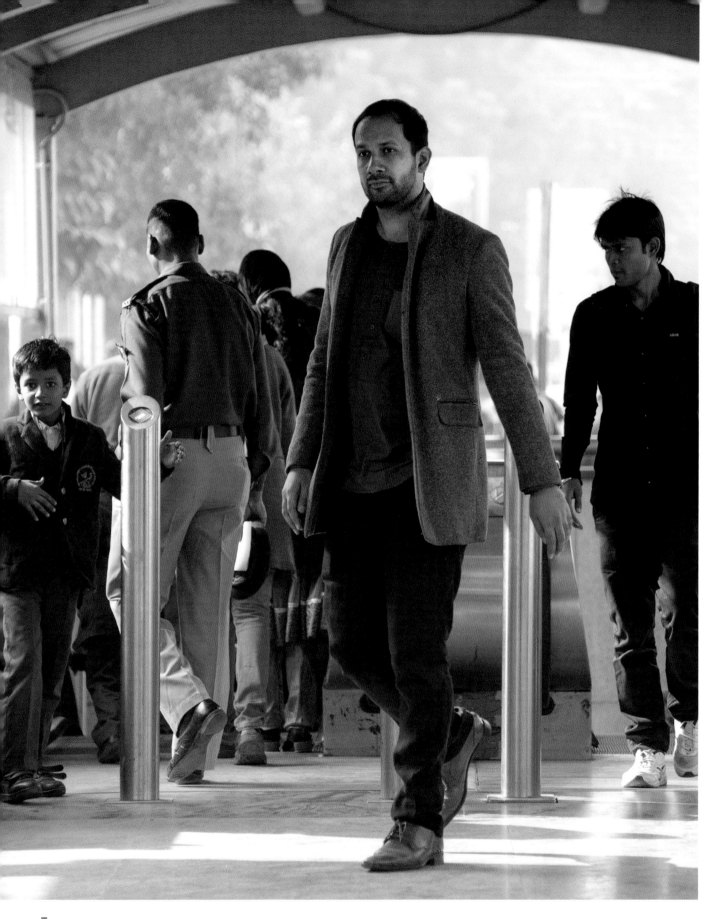

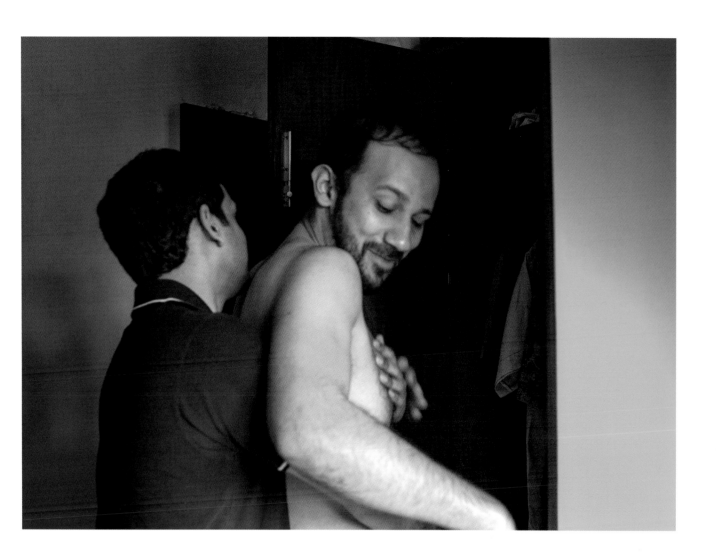

I was born in Delhi. I grew up here. I have lived here all my life, did my secondary schooling here and the rest in the U.S. I went at eighteen and came back at twenty-two. It was somewhere in probably around early high school that I had a sense that I was attracted to boys. I didn't have any actual relations. There were no effeminacy issues for me.

It was in college in the States that I had my first gay experience. I told my parents the first summer I came back from college. I was very lucky that I didn't have to confront fear or self-hate. There are two kinds of people: those who are extraordinarily brave and those who have the privilege to do what they do. I belong to the latter. Meanwhile the criminal justice system did not have the impact on me that it had on so many other gay lives. But I had to find a way to have a successful professional life, and it led to my decision to join the academy. I decided to be very publicly out in all my workplaces. I felt that if I was uncertain, then the institution would not stand by me. That was the biggest thing for me, the impact on my work. I know I lost a lot, but enough has remained. »

I never went online and I never went cruising. I had encounters. I live in a big city and I had constant encounters. There were moments when I felt very exposed—the other person could make my life hell—so I've always been prepared. I've been to enough police stations getting my friends out, so I know the everyday life of the law very well.

I've been in a relationship for about five years. It will never have any legal standing. As we are both young, it seems not to have much impact. He's not very out to his family. But this might change as we get older. We are not co-habiting. I live with one of my close gay friends and our neighbors know.

I feel the law around me. I felt it when we went to colleges and spoke to young kids and they said, "But there's the law," as their parents did as well. I felt it when we tried to raise petitions or speak to anyone in the government. They said, "But there's the law." After the first judgment, we could discuss passing anti-discrimination laws in the workplace. Groups like Queer Campus were possible. A lot of us felt the law was a metaphor for prejudice. It was a criminal law. After 2009, a certain part of our freedom became undebatable. You could talk about moral disagreement, but you could not question the basic legitimacy of queer people. We don't feel like we can go back as so much had happened between 2009 and 2013. The legal case is still going. It keeps us alive. Now we have other institutions and campaigns behind us. That helps a lot. A multiplicity of strategies is the way to go now. ■

Rahul was born in Delhi, the only son in a traditional South Indian family. As the eldest son, he has the responsibility of maintaining his family's reputation and its financial well-being. His sexuality is never discussed by his parents, who treat his partner, Gautam (photographed earlier), as a "friend."

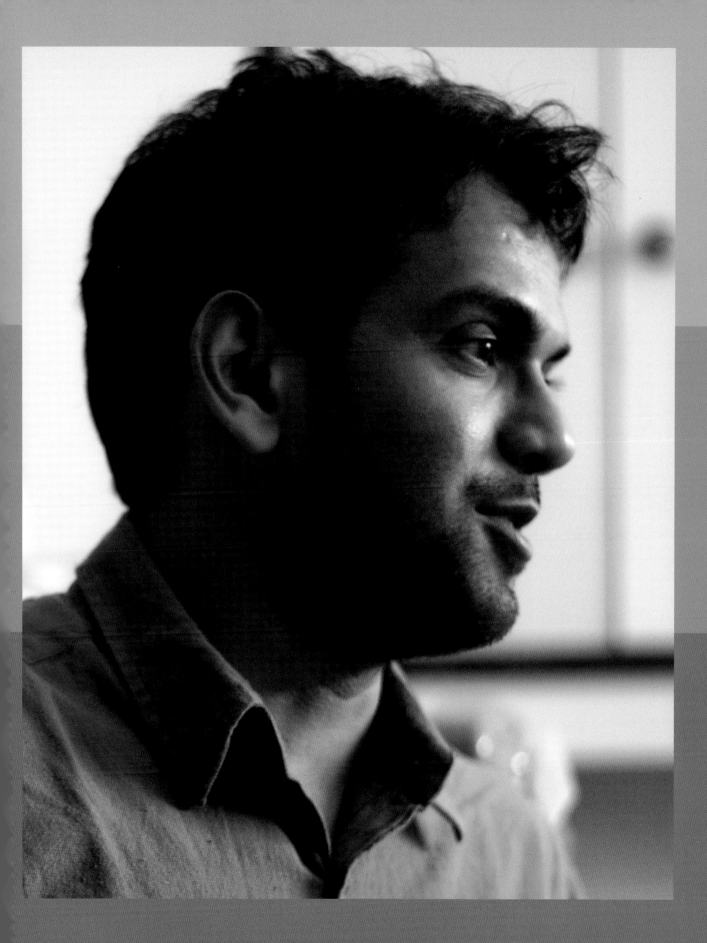

I recently turned twenty-nine. I came back to Delhi about six years back. I feel more comfortable in Delhi so I feel like a Delhite, but I'm originally from Andhra [Pradesh] and Tamil Nadu. I considered myself gay. Now I consider myself queer.

What I remember very clearly is not my Delhi childhood but my Bangalore childhood, which was not much fun. Till around twelve, I was openly effeminate. I was free, I used to run around wearing my mother's clothes and threaten to kiss boys in class. I was comfortable being effeminate. Then suddenly there was talk about my effeminacy in school, and that's when I went into a shell about my sexuality and became straight-acting.

I think I delayed coming out because of family and because of school. The first person I came out to was the boy who became my boyfriend for the next two years. This was when I was in college. After my first boyfriend left, I was alone for two years. If I find a small group of people, life is fine, but I guess I'm a little introverted. I never went to a gay party in Bangalore. I had a trust issue about going to people's houses. It was difficult with the gay scene. It was either meetings or parties, and it was costly to go out and I didn't have the money for that. »

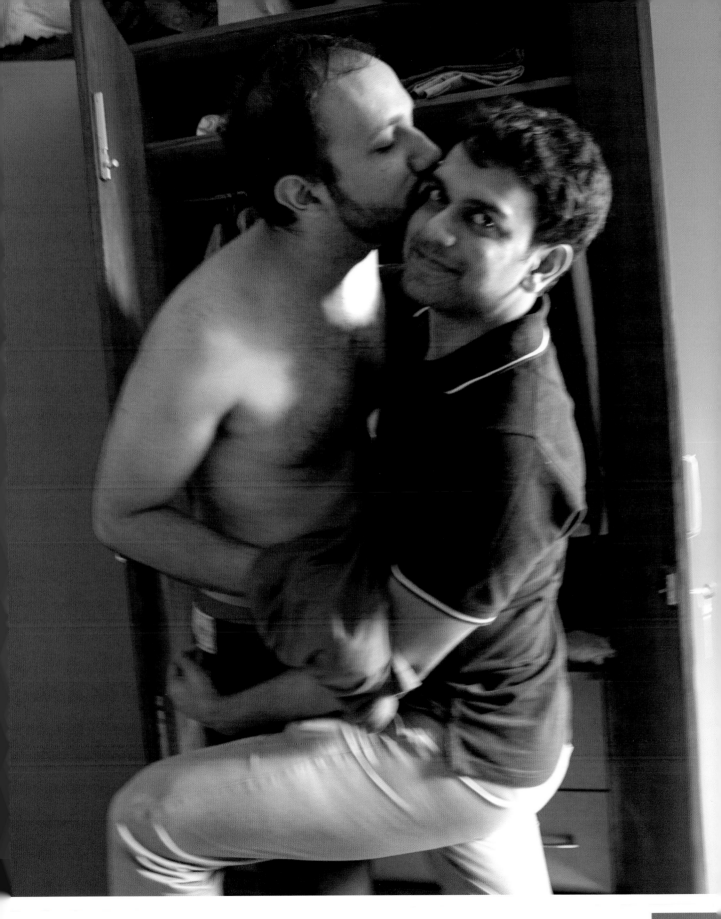

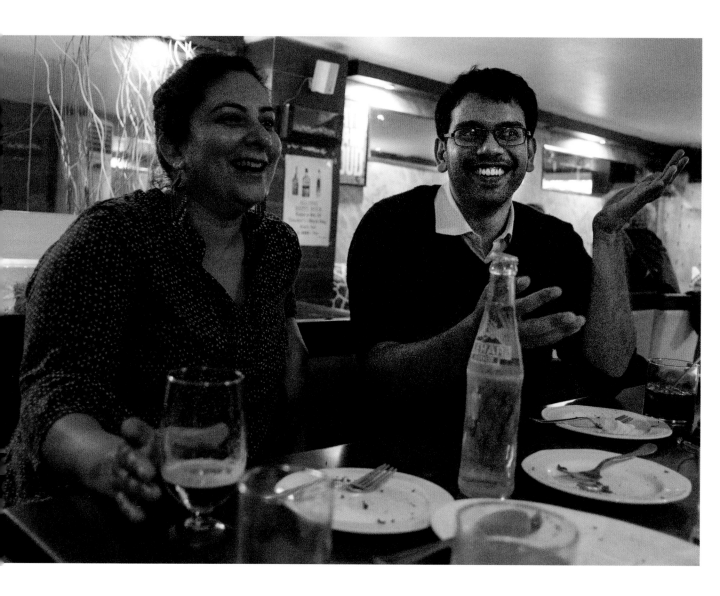

When I came to Delhi just as the law changed, my entire life changed in one night. I met the person who would be my boyfriend at my first gay party. Earlier I did think that I would be vulnerable by going to a gay party. I met the person I am dating about five and a half years ago now. Even today I have no relationship objectives about marriage, a joint account, etc. And through him, I met a group, and it was a very critical moment and a critical group, which gave me moral and theoretical support. I come from a dysfunctional family, and early in life I acknowledged that there was something wrong with the notion of family. We are obsessed with family in this country. We need to be more critical of family. Why should people have to give love and money unconditionally? The queer family I have built up over years and years is more important for me. It's not easy to build a queer family. Most people are stuck in biological families. Living alternatively is not done. Peer and family pressure has a lot to do with the decisions gay people are making.

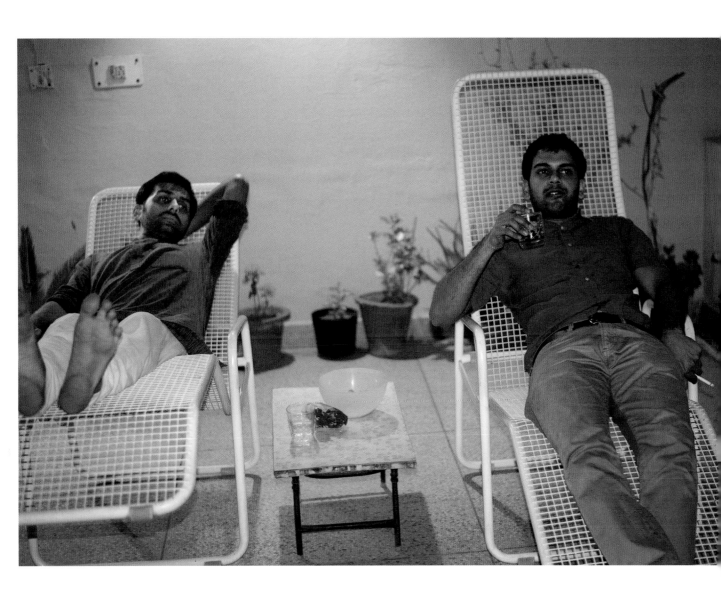

I heard about Section 377 quite early. I must have been eighteen. Since I wasn't going out much, it didn't seem to apply to me. I was more concerned about what the law means to me in terms of dignity and rights. In Delhi I got more actively involved in work about the law, training workshops, etc. I also did some workshops at Delhi University to talk to college kids about gender and sexuality.

My understanding of this law's reversal is that it has very little impact on me personally because of my position of privilege. But I was very saddened. It was an emotional reaction. I cried. What really saddened me was that what the judge delivered had nothing to do with the law but all to do with his personal bias. ▪

Lily was born as "Akash" to a conservative Hindu family. She left school before ninth grade and, now in her thirties, lives with her parents in Delhi, where she is a member of the *hijra* (trans women) community. She dresses in women's clothes and dances at private events to earn a living.

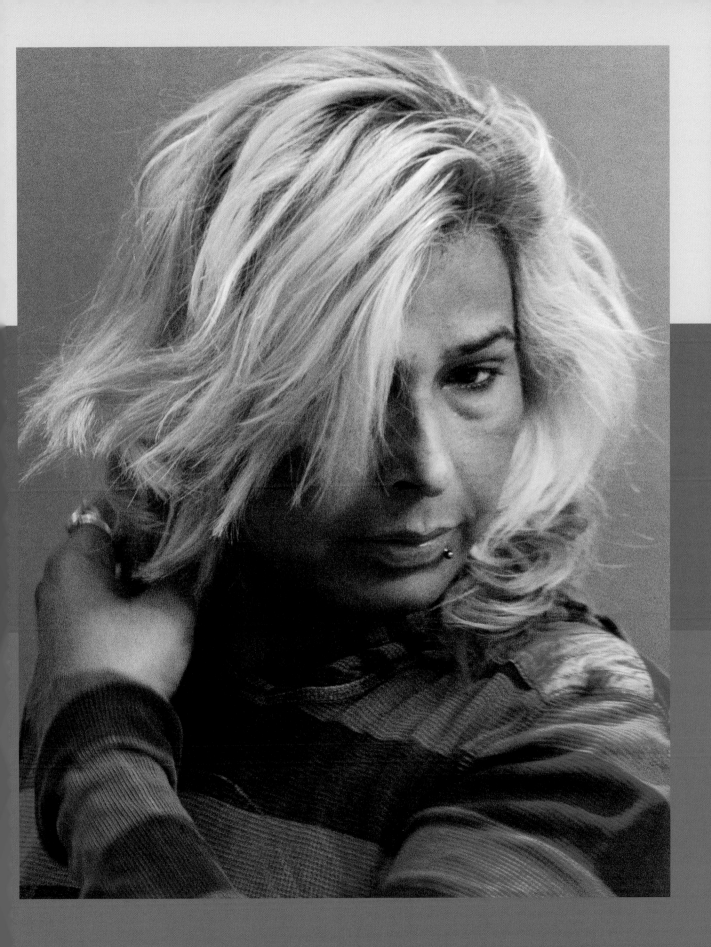

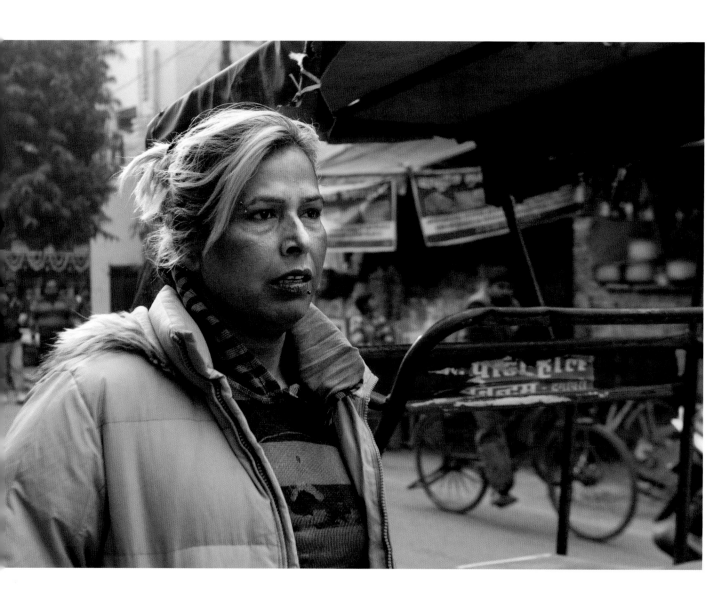

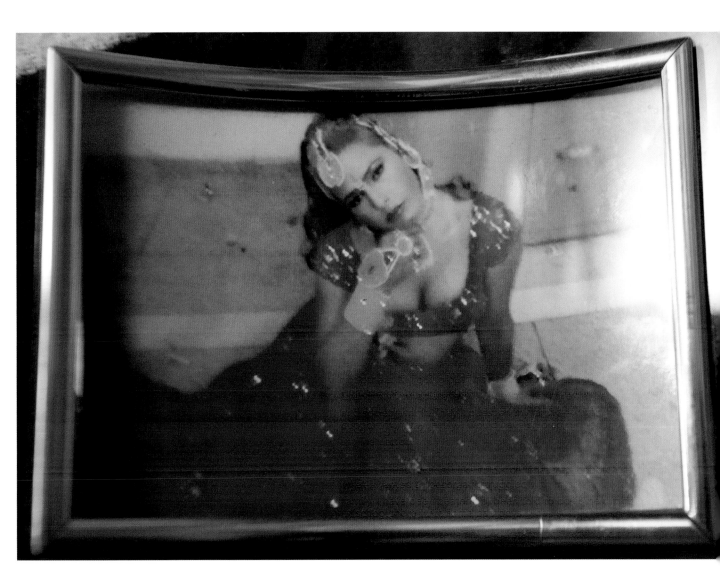

I am from East Delhi. I have studied up till ninth grade. I like to dance. That's my hobby. That's how I came into this "line" [*smiles*].

In school there were some bad boys, who I suspected knew about homosexuality or indulged in it, who used to taunt me: "You look like a girl and you behave like a girl." So I quit the school. If I had support from my family, I would have studied further and made my life better.

I learned that I wanted to be a girl when I was sixteen. That was what I wanted to become. I struggled with myself and with my family. I have been beaten up, been told to do some things and not others. My going out was restricted. The struggle continues. Even if my immediate family understands, my extended family and society won't. They'll question my family—why is your son becoming a girl? »

I was interested in dancing. I am a lady dancer. I get to dance events, weddings, stage shows, etc. Then I also got involved with *hijra* culture. We danced and performed *toli-badhai* [a dance and blessing performed at auspicious occasions, e.g., a wedding, birth, festival, housewarming, or the beginning of a new business] for a while. I still do. It's not like I cut them off. I am still part of their culture. »

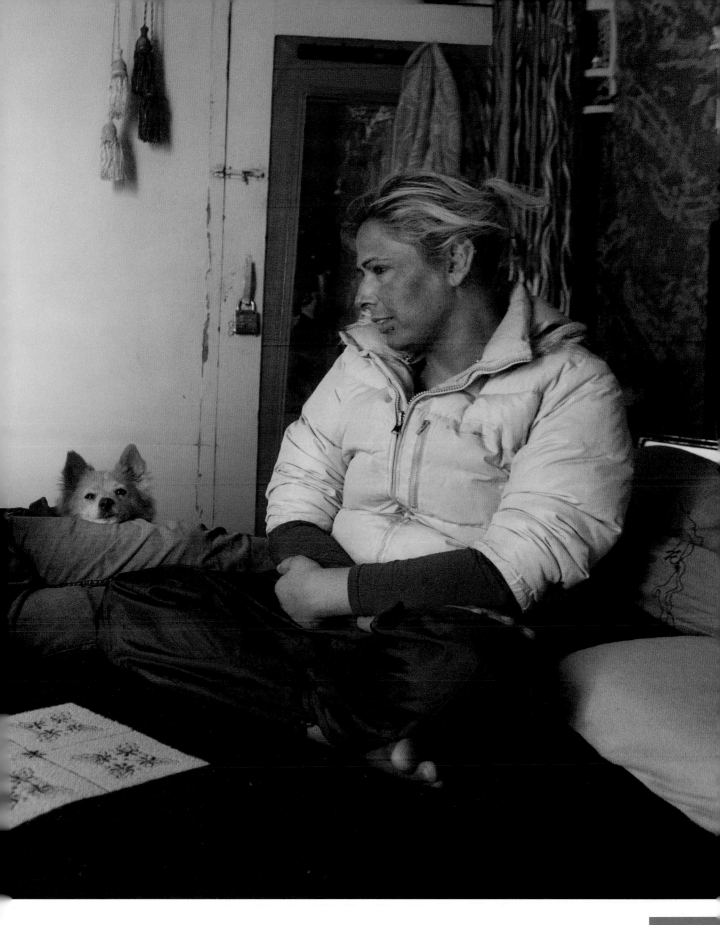

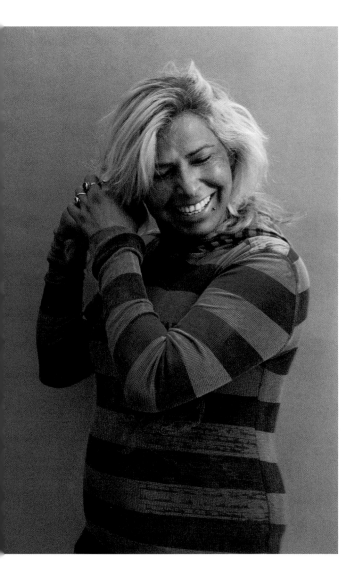
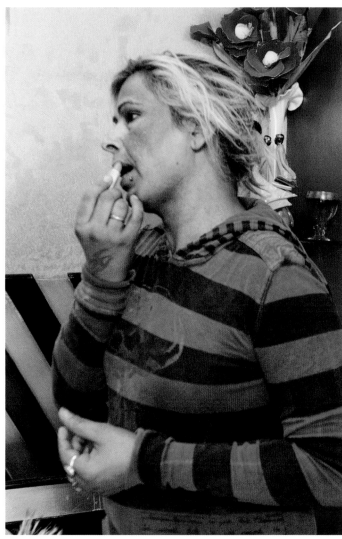

People would say that I am soliciting if I just walk on the street. Police will harass people like me. That's, like, normal for us. The police are not supportive when we want to file a complaint. Instead they humiliate us and even force us to have sex. So how can we have the courage to fight? If the law were with us, then these humiliations could be better challenged, and these harassments could be dealt with.

Society has this misconception that we don't want to have a partner for life, but if we were allowed legally to marry and live openly, we would. We do have marriage-like partnerships in our culture, but they are not recognized by the government. Many times families destroy these marriages because there won't be any descendants.

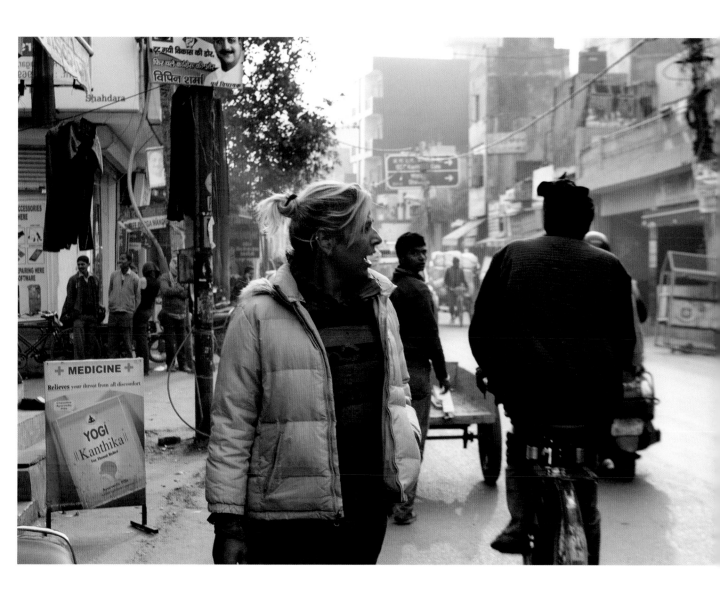

Recently there was a change in the law. We can apply for government jobs. This exposed such extreme prejudice. People said that we will corrupt everybody in the department. So it's all in the mind. We are capable of doing many things. Unless India, its people, and society change their thinking and their attitude toward people like me, I will not have a better life. Nothing will change. ■

geeta

kath

Geeta lives part of the year in Noida just outside Delhi and the rest of the year with her American wife, **Kath**, in Virginia, where they both teach. Geeta comes from a wealthy upper-middle-class family in Mumbai and only felt comfortable coming out in the United States. Recently, having inherited a home in Delhi away from her immediate family, she has been returning to India more frequently.

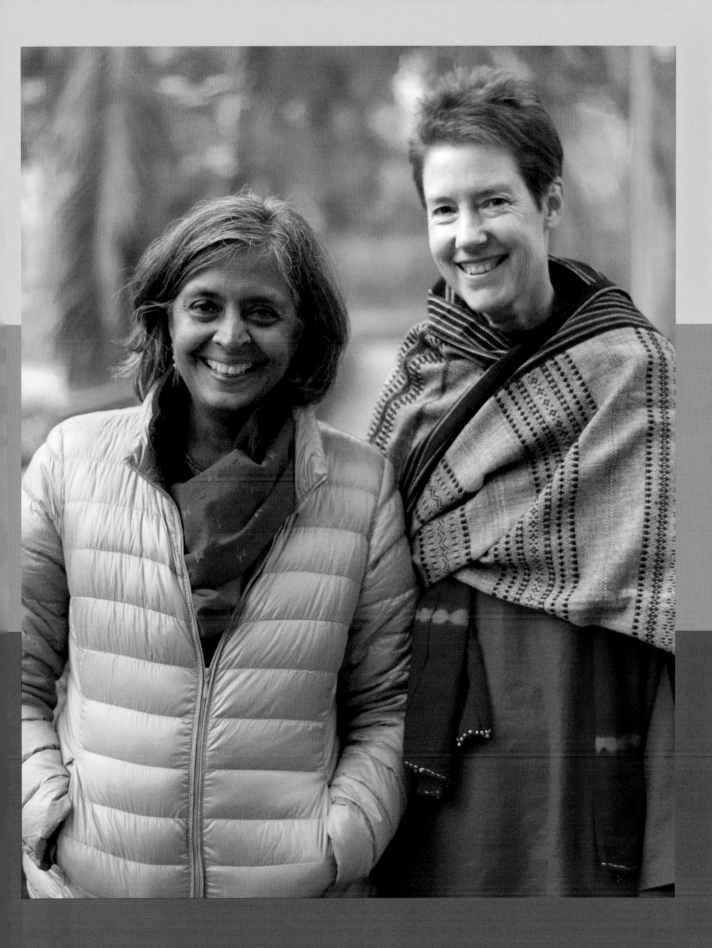

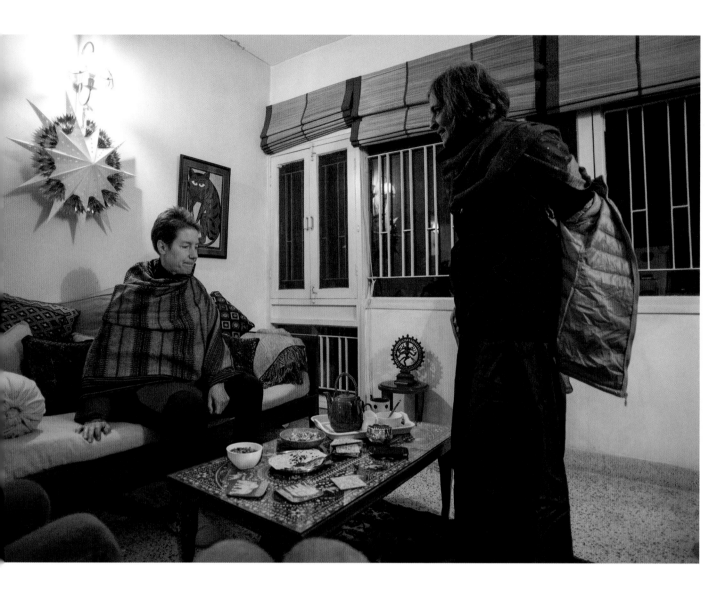

Geeta

I never thought that I would be queer. I liked boys. I went to a school and college in Mumbai, then in South Wales. I came back to Delhi and did a BSc, and then went to the U.S. and did another BSc and that's when I found I was gay. Coming out in Boston and New York in the 1970s was wild. I fell in love with a girl, and then with another girl. I started doing activist work. I worked with a women's shelter, and then did HIV work in between.

India was very complicated for me because I came from an extremely brutal family. When you grow up in a household that violent it's very hard to figure out how to survive. Basically I've been on scholarships and loans through my college. I didn't come back for many years because coming back would have been really hard. People think I didn't want to come back because I was enamored by the West, but actually there wasn't a safe place to stay here.

I had no need to look for clues on homosexuality partly because I had them studying Sanskrit and Urdu. For me, finding queer stuff was just part of my reading. There was no sense that I was hidden from history.

People from the *hijra* communities have been making communities for a long time—households and places to live, places that are ordinary. I was never very straight. I saw myself as a boy-girl. The attachment to transgender communities went against my class. My class couldn't do anything for me, so my class status had to be changed.

Way before the first judgment, there was a feeling that the work around the sodomy statutes was more underground. There was a kind of tentativeness. Then as it came to the courts, there was a feeling of incredible possibility, so there was a shift toward a more public discourse. After the judgment there was euphoria and people felt as if the work had been done. »

I was here in Delhi when it was overturned. Everyone was in shock. What was interesting was the difference from the 1990s. I felt that this time there was a lot more support from different communities in India, more than there would be in the U.S. After that and after the national election in 2014, it's not gone back to the 1990s. It's a different kind of incipient conservatism. The violence has escalated. The second judgment has given people the vocabulary to be homophobic. It's made things much harder. There's melancholia. It's more than grief. It's also made my family slightly more open to my relationship. It made people come out in support of queer rights.

It matters to me that I'm in India. Sometimes it's hard to be here. It's hard to explain that I'm married to Kath, but that's hard to explain in the U.S., too. What I was hoping to do was to have my relationship with Kath be simply ordinary. I feel like danger is stalking us in a much more different way.

Kath

I grew up in the United States in the 1960s—just outside Chicago. Geeta and I met in 1992, but it wasn't until the following year that we began to see each other. Because of how Geeta and I look, because of the racism and skin-color politics in the United States, and because of our upbringings, our experiences on both sides of the world have been very, very different.

The greatest challenges have come as we have tried to figure out how to spend time in India, to live in India. As you can imagine, it is all the more difficult because I have no legal right to reside in the country.

When I met Geeta, I had been out for many years to friends, family, and employers.

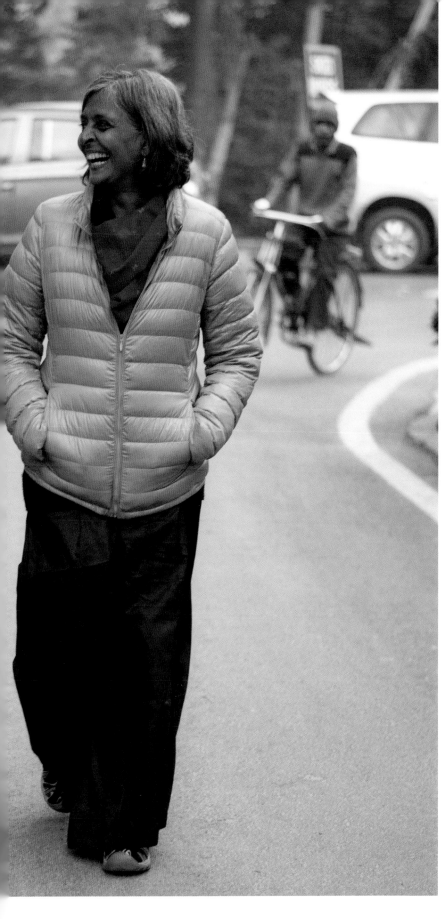

Given the topic of my first book, *Families We Choose: Lesbians, Gays, Kinship*, I almost had to be. Geeta was not out to most of her relatives at the time I met her. That was sometimes hard to manage. But because there was so much more space for public affection between women in India as opposed to the U.S., India could also be an easier place for us to be.

As for the legal situation, it means the power to determine when or whether we can spend time together in India is not in our hands.

We started living part-time in northern India in the mid-2000s. I pay attention to the legal ramifications as part of my work. I have written essays on the struggle to legitimize LGBTQ relationships. I am very aware of the potential impact of laws that criminalize homosexuality. It's never good to leave a weapon in the hands of those who might wish you harm.

Yes, the 2009 judgment definitely made a difference. It was like a window of possibility had opened to a life without the constant anxiety of forced separation. You could see the difference it made for our circle of friends in Delhi and beyond: to be treated as everyone should be treated, with dignity, with respect, with standing before the law.

What happens as we get older, when one or both of us becomes infirm and cannot travel for health reasons? What happens if plane fares rise and we cannot afford to go in and out of the country once we are living as elderly people on a fixed income? What happens if the government decides to change its visa regime? Imagine what it would be like to be caught out like that, unable to go to the bedside of the person you love most in the world while they were ill or dying! It's unbearable. ◼

A graphic designer, **Pavitr** comes from an affluent family in the old part of Delhi. He has been active in the earlier stages of the queer movement and is open about his sexuality to a degree. He has moved out of his parents' home and shares a flat with Gautam. He is single, but has a busy social life.

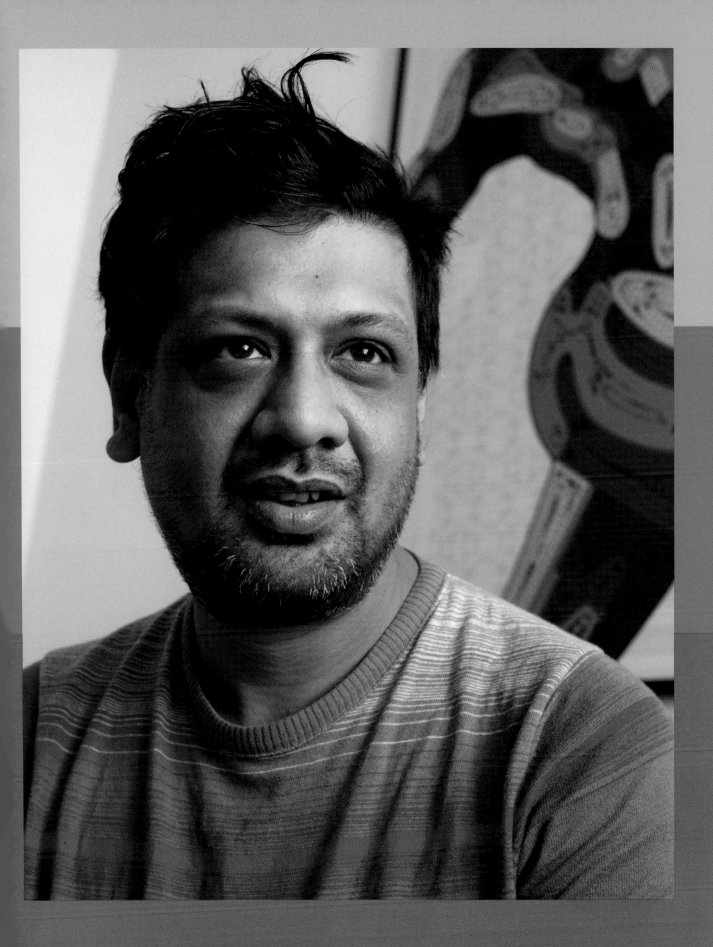

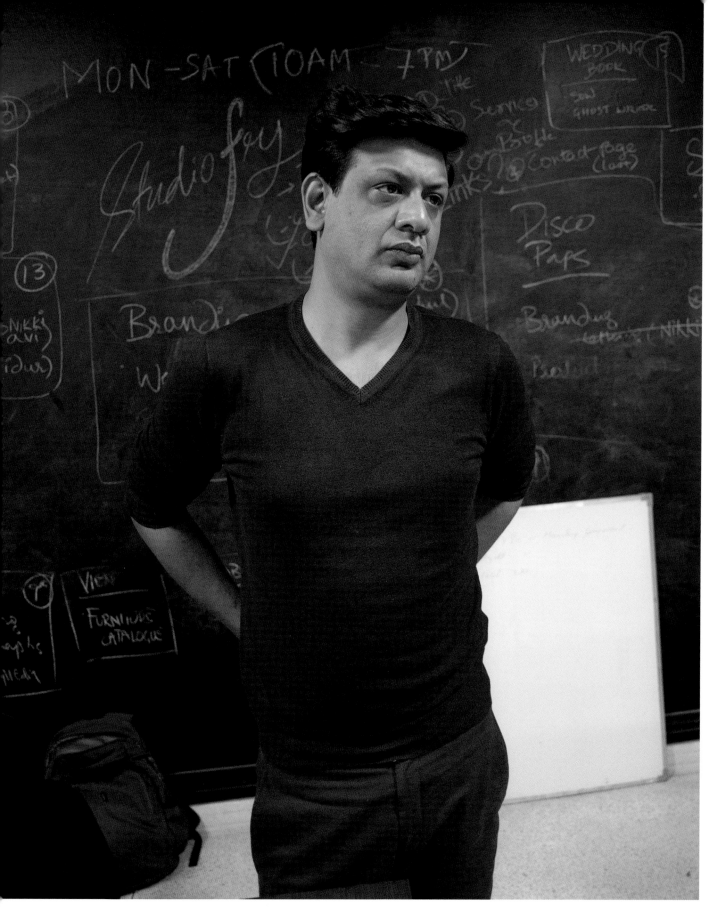

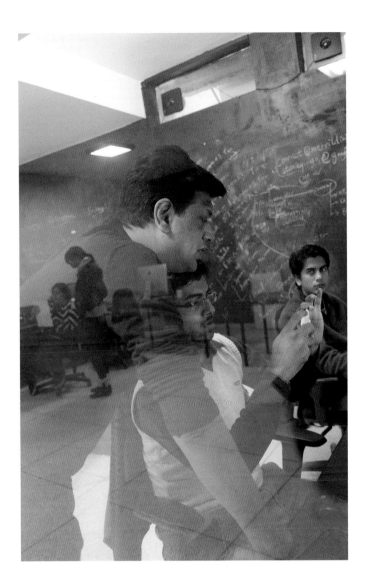
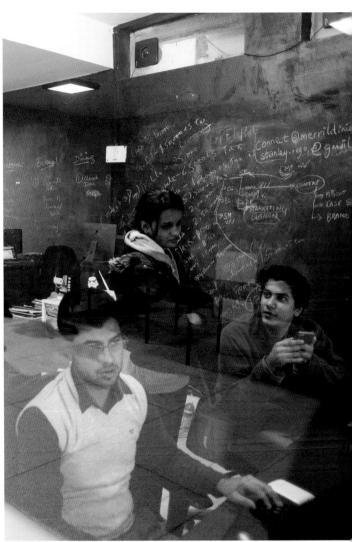

I'm from Delhi. I've always been here. Only did secondary school and did not go to college. From the age of ten, I had a boyfriend. There was a definite sense of "this is not acceptable to anybody else." To a large extent, it felt like a situation completely unique to us, just the two of us.

After I broke up with him, there was a sense that I knew that I was gay. The Internet had just come into the country. I met someone online who convinced me to come and join a support group called Humrahi, and he made it sound like it was a roundtable conference where people sat down and talked about sexuality. I got fully involved. Although HIV/AIDS was happening, it didn't feel scary. I hadn't gone out much and I didn't know anyone who was infected. The awareness of the legal situation came from Humrahi. That's when I realized that it's not just frowned upon. You could go to jail for it. That was bad. Most of the media was becoming fairly positive. That helped conversations at the dinner table at home with my parents. »

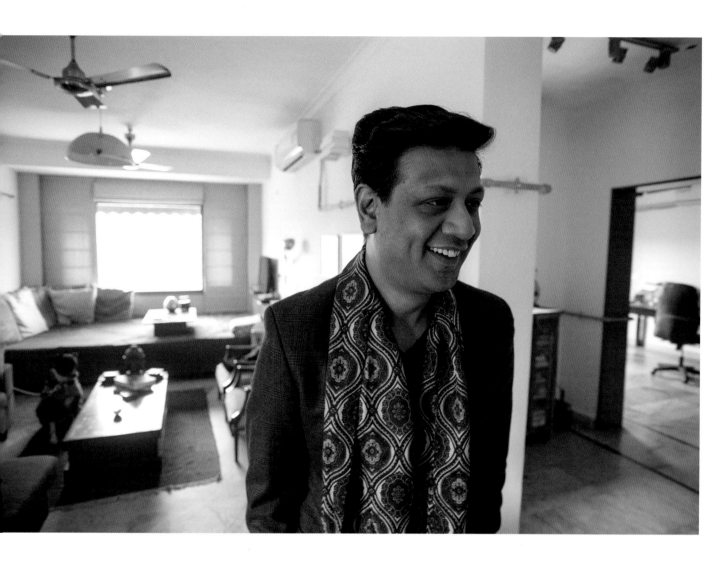

A vibrant social gay culture emerged until the murder of a gay man, which was sensationalized by the press, and it was all shut down. Fear went skyrocketing. There were still parties without anxiety of imminent arrest, even if it was illegal to be gay, but there was anxiety for newcomers. The first set of parties had all sorts of people—from across class. I think the early parties were more egalitarian. There were fewer people and you hugged whoever was around. People were less judgmental than they are now. There wasn't the transphobia.

I never hooked up through cruising. There was always that underlying fear. I was using the Internet. My family didn't hassle me after I came out. From then on there was no marriage pressure.

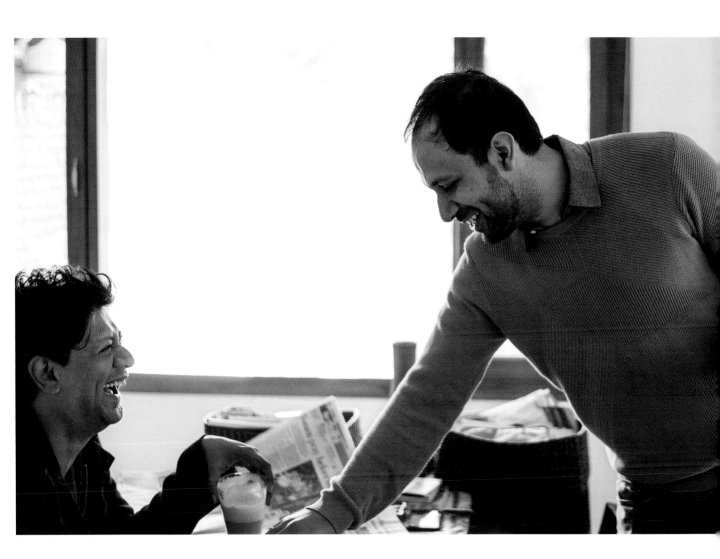

I didn't expect us to get the first judgment, but when we did, it was incredibly emotional. It made me feel a lot more hopeful about the kind of life I could have. It legitimized us, which was great for everyone. One of the problems that I have is that there are no out gay men of my age around. If other guys could be more emboldened to be out and to be less afraid, it would give me a bigger chance of being involved with somebody. I had stopped hoping that that would happen. That's of direct relevance to my life. I had never thought that the activism that I do for anybody else could lead directly to the betterment of my life. When the judgment got reversed I was very pessimistic. But that hope hasn't died out completely. At some level it's allowed a lot of guys to open up about themselves, and that process can't be reversed. It's better than before the first judgment. There has been a lot more education, especially among younger people. They are much more gay-positive. ■

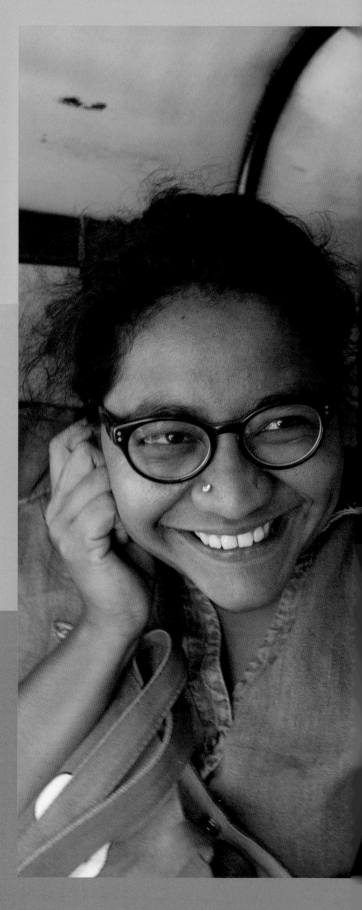

ponni & indu

Ponni (left) is a queer feminist researcher and has helped found various activist groups in India. She grew up in Chennai, Tamil Nadu, in southern India, and has a degree in law and history. She is currently pursuing her PhD at the University of Toronto, where she is examining the history of Tamil Nadu from a feminist perspective. In Toronto, she lives with her partner, **Indu** (right), who is an activist, writer, and visual artist. Ponni is known, among other things, for writing a legal guide for young lesbians in India on how to run away from home.

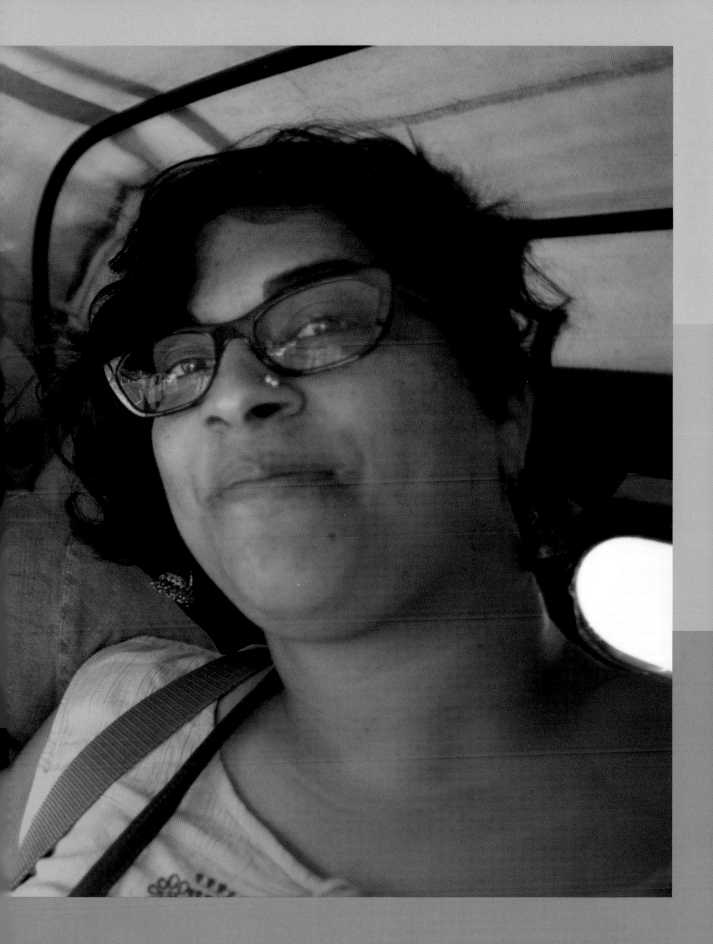

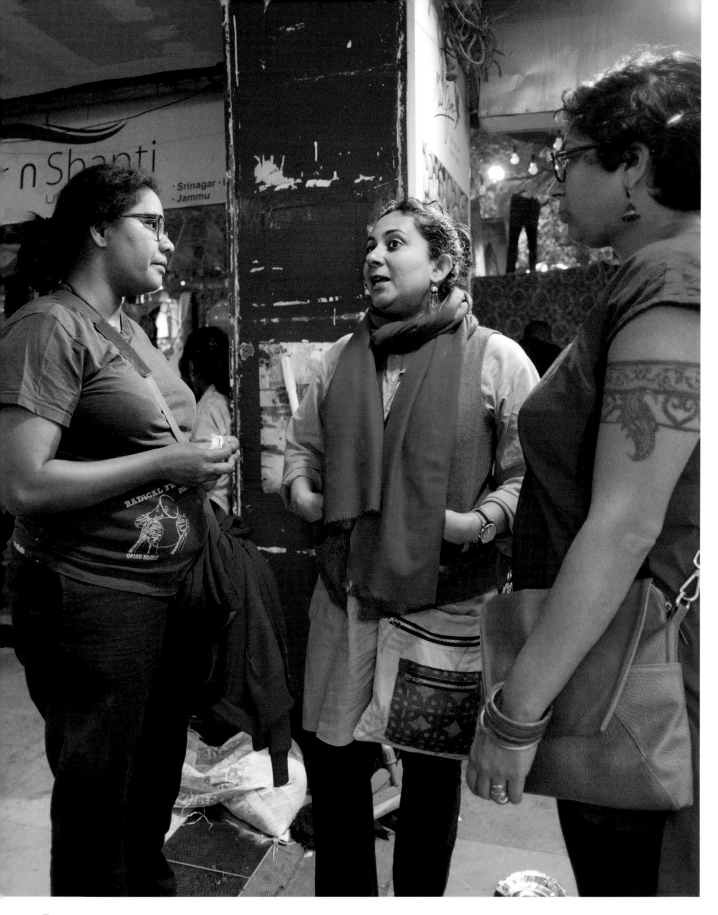

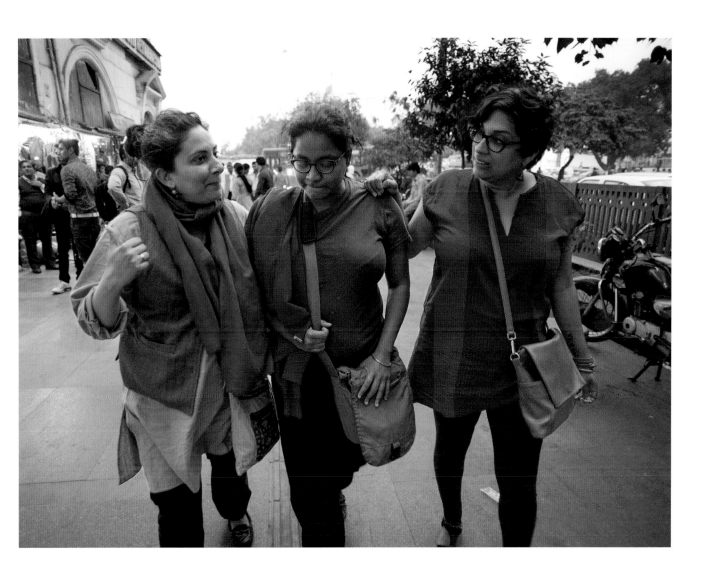

Ponni: I've been describing myself as a Tamil queer feminist. I am part of the queer movement in India as a legal practitioner in the case against Section 377, in my capacity as researcher, trying to evolve our own indigenous versions of queer analysis of archives, and I'm out in the public sphere in Tamil.

Indu: The 2009 judgment emboldened me. I'd come to a point in my life in Canada where I felt it was hard not to be out. I wasn't sure how to be out. That's when I decided to go to India on my own and find my queer family. There was so much marriage pressure. I thought if I found some people in India, they would help me. I didn't know any people. Then I wake up on July 2, and I'm listening to the news, and I hear Ponni!

Ponni: My BBC interview, where I was arguing with a father of a church. I was exhausted because I was so tired. The father was telling me that we are all his children but we shouldn't disturb the family. So I said that if you love us so much . . . »

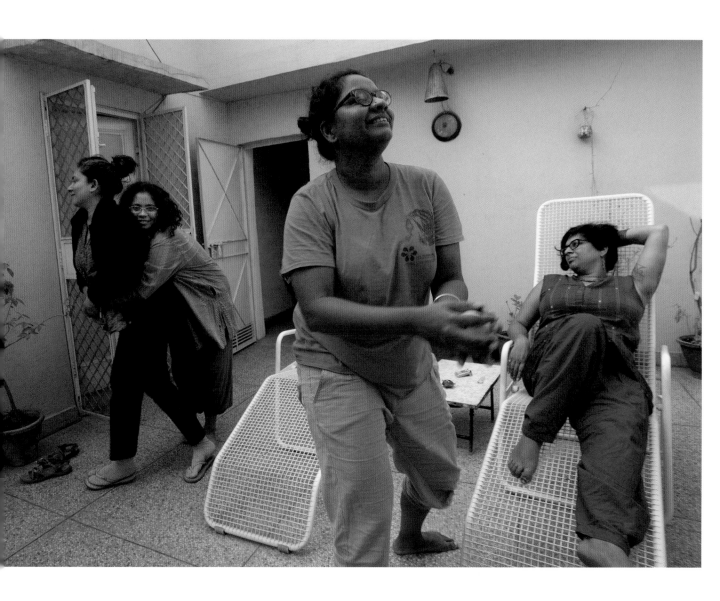

Indu: I listened to this interview and I thought this is the right time to go. I went to Bombay and I liked the people I met. On my third trip, in 2010, I decided to come out to my family, and having an Indian network was really important. The way I found people in Delhi was by word of mouth. Their online presence was really bad, but people introduced me to other people. Someone had to bring you in who knows you. They have to have that point of entry or no one responds to you. It might be a safety issue.

I haven't been back since the reversal. Now although there is more knowledge about queers, there is more homophobia. Before it was difficult for same-sex couples because of the patriarchy, now it's because of homophobia, which has made us more visible.

I'm in a relationship with somebody who is from India, and we don't have the same rights in either country. Whenever there is an issue, all the foreigners get deported and can never get back.

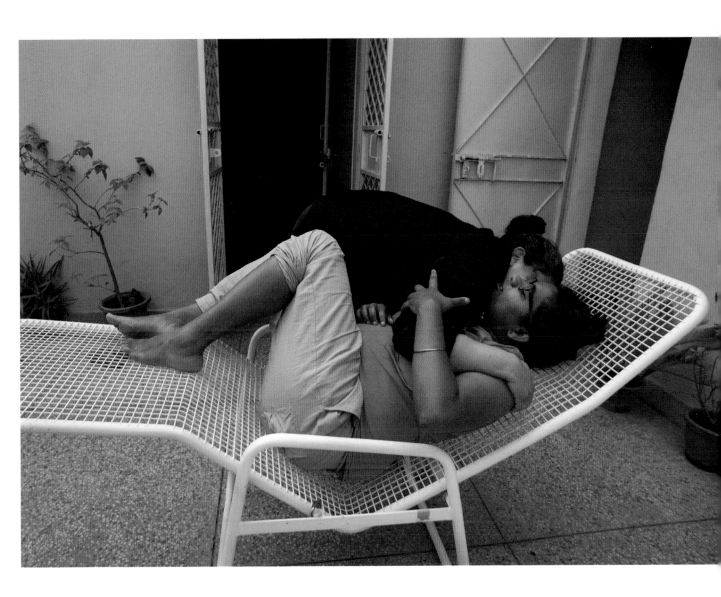

Ponni: Both the judgments are important in my life. There has been an ongoing debate about visibility versus the law. We created this narrative about oppression and liberation and the law. But I had a moment when I felt that I had brought liberation to a group of upper-middle-class men who didn't care about anybody else's rights, and I had a political breakdown. I distanced myself from this movement after 2009. So I moved to Tamil Nadu and worked with sex workers. Now I'm slowly coming back, but differently. Section 377 still has to go, as it comes in the way of folks who want to live non-normative lives. The questions about how the law affects our lives carry on. The Constitution of India is set out so that even if one person is being discriminated [against], the country and its laws must protect the citizen. Those who say the law doesn't matter are leaving privilege unquestioned. ■

Deepti is a queer feminist activist based in New Delhi. She has been part of Saheli, an autonomous women's collective, as well as many queer political spaces in the city for a long time. She has made her life in the city in several precious homes. Each of these homes has been an experiment in living a collectivist community life, open to many a misfit and those seeking a safe space. As this is written, she is excited about embarking on yet another experiment where her erstwhile community cupboard expands into an open house itself.

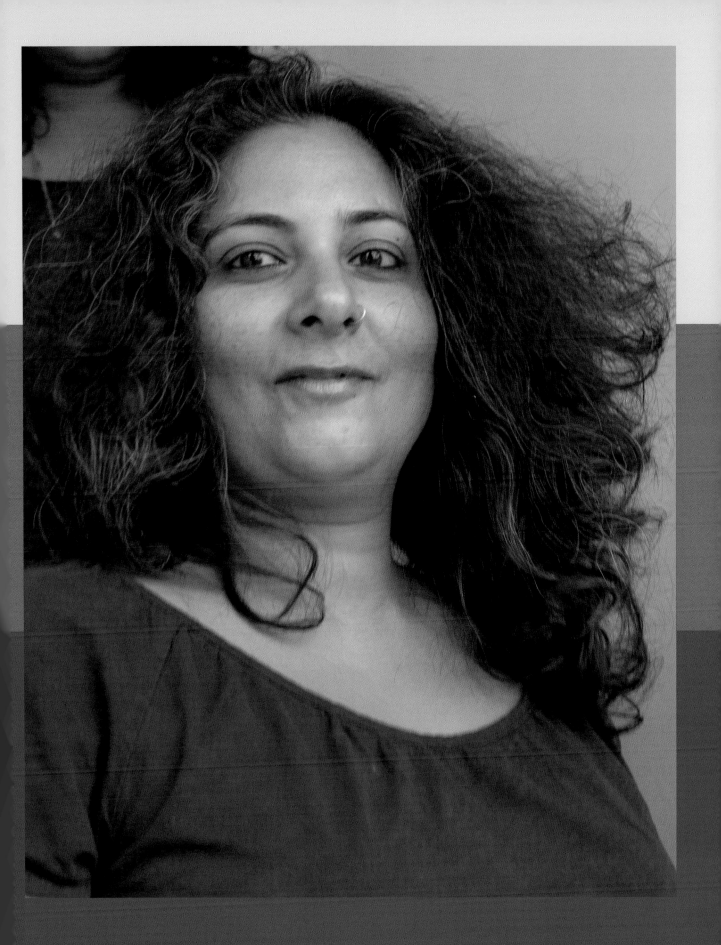

I was born in Delhi, where I lived with my parents. That's where I had all my friends, my community, and I learned all kinds of things. It was where I grew up as a teenager, and it was also the place where [I tried] all kinds of experimentation, leading to the awakening of my own sexuality. My childhood was very happy. My parents were always fantastic. Even at college, I never for a second thought that I was attracted to women. I just felt that I shared a very special relationship with my women friends. It wasn't sexual. It was very close. The closeness was also protective. I'm still protective of my friends. But nothing sexual ever happened with any woman. I was only interested in boys.

I'm shocked how moralistic I was in my early twenties. My aim in life in my teens was to get married. I used to tell my parents, "The minute I'm eighteen, I'm out." Fortunately, my parents didn't think marriage had to come right after college. Meanwhile, my earlier notions about the women's movement were that it was a bunch of extremely moralistic women who feel the need to take up social causes. I studied business, so I had never read a single book about feminism till I was twenty-five. My life was changed by a chance encounter. I found myself in a space where I was part of a group [Saheli] that was fighting along with some other progressive women's groups who argued that the foundation of patriarchy is its control over women's sexuality. They also thought if you can't talk about class or caste, then you can't talk about feminism. But there was no conversation about sexuality. »

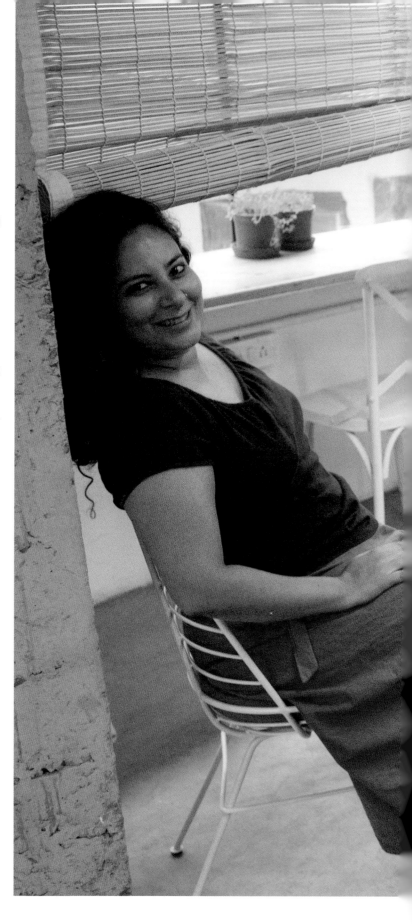

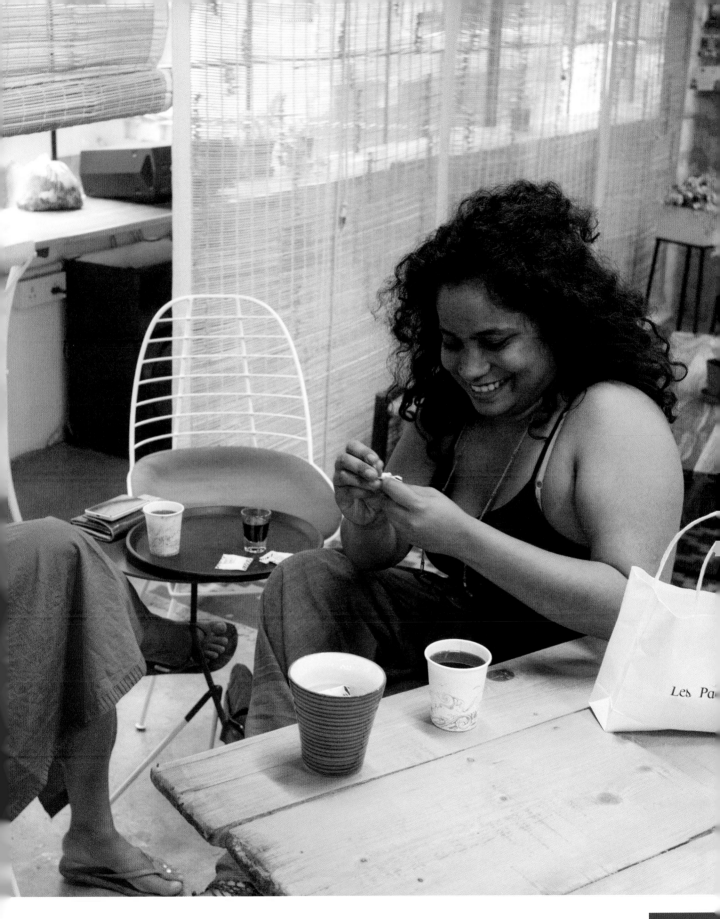

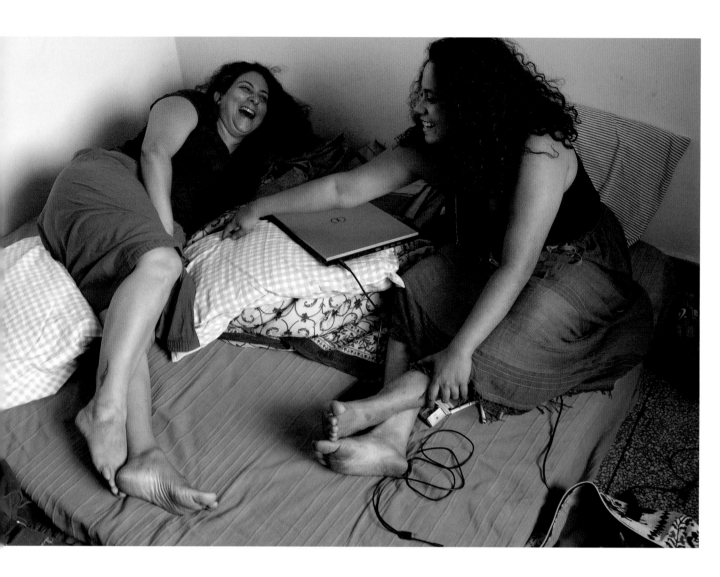

The minute I was in Saheli, the question of my sexuality just came so naturally to me without conflict, contradiction, or guilt. It was a really good moment for me to come to terms with my own sexuality because there was nobody to judge me. It's a community that allows you take risks, emotional risks, etc., because they will not let you fail. I knew that I will not be alone facing Section 377. I was in the throes of passion with a woman, so who gave a shit about the law? I was twenty-seven, and I was having a relationship with a woman for the first time, and it was the first time for her. We didn't care about anything.

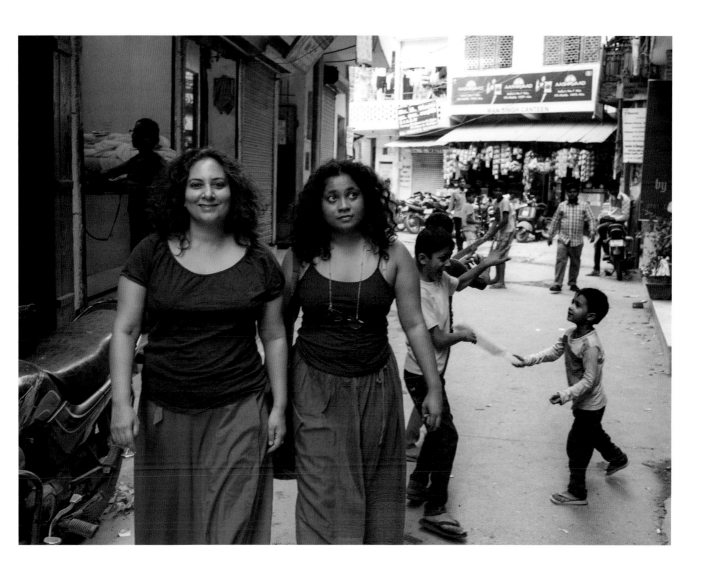

I feel angry with the entire reversal by the Supreme Court judgment in 2013. From the time of the High Court judgment in 2009, a whole bunch of queer people came out to their families, colleagues, and neighbors because they felt people's perception would now change with the change of the law. Now, all of a sudden, you are more vulnerable because you are a lot more visible.

The government is not banning Pride marches because that would instantly label them internationally as homophobic, and they care about their image. But they will not overturn Section 377 any time soon. Their agenda is about controlling people's lives and their thinking. If there is a personal threat to my freedom, I have friends and community who will support me, so I can afford to take a risk. ■

Akshara is a queer feminist who is currently writing her thesis on the *Bhagavad Gita*, a Hindu scripture. She is part of a New Delhi–based feminist collective called Saheli that works across the nation. She is also part of the queer collective Nigah. Akshara is openly bisexual, which some in the queer movement have seen as an "escape" toward heteronormativity; however, Akshara fully embraces her sexuality.

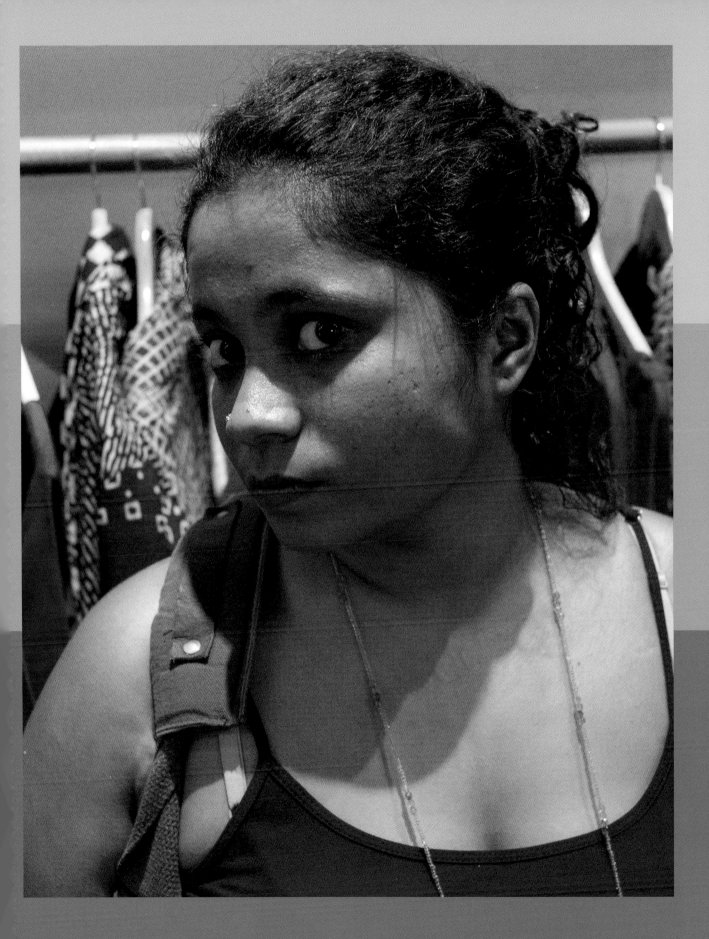

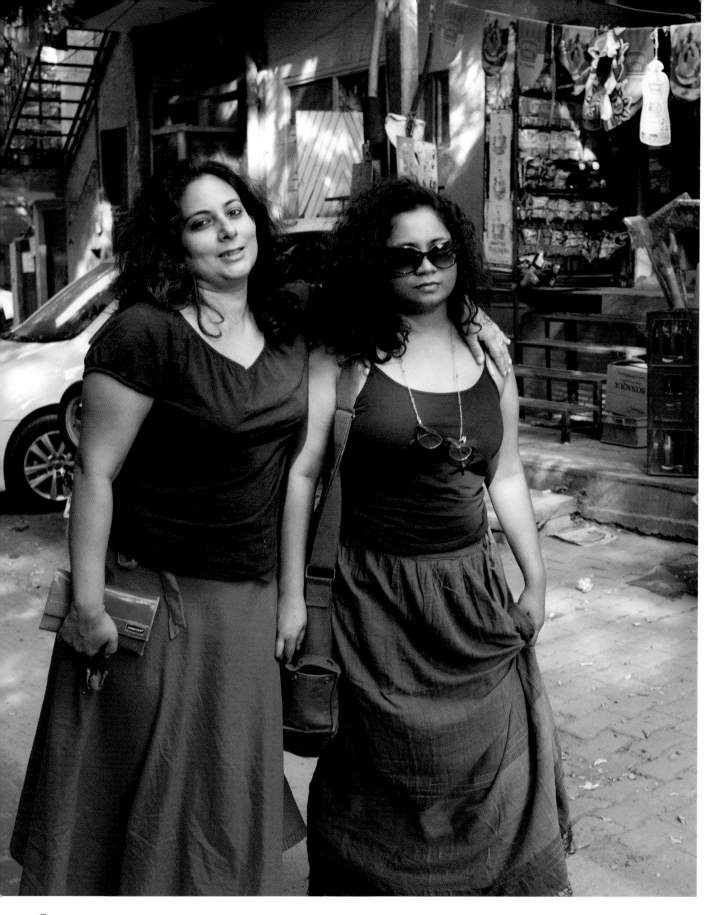

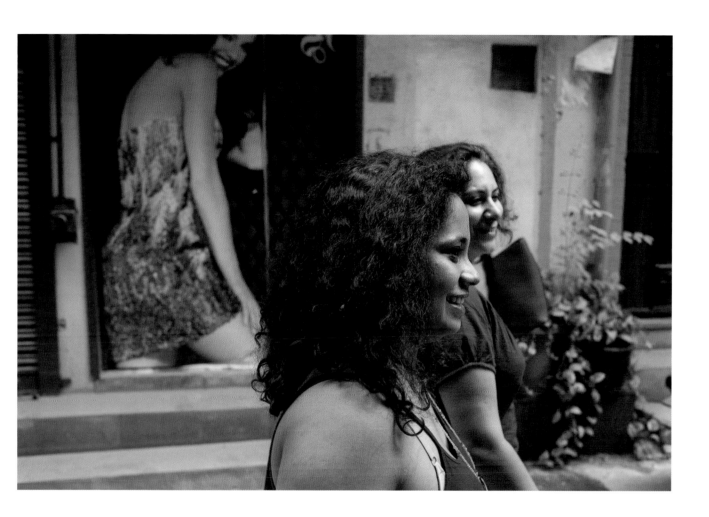

The first time I met a woman was in Delhi when I was eighteen. I've had a range of responses to my bisexuality. In college, people said that I was just saying that to show I was really cool. There have been moments when other queer people have made me feel bad about being bisexual.

My mother knows, but we don't talk about it. My father doesn't discuss it. I don't feel it's necessary to discuss this with him. Even if I'm dating men, I don't tell them as they would immediately bring up the issue of marriage. I'm twenty-seven and still living in their house.

I am lucky, though, to have friends and political allies who don't have an issue with my sexuality. Queerness is a different way of thinking about relationships and other kinds of friendships in your life. Even heterosexual relationships do not have to lead to the same normative structures of marriage. »

A lot of my ideas came through my mother, even though she's never been politically engaged. For example, when we watched Bollywood movies, she used to point out a lot of misogynist tropes. Then I started reading a lot. At Saheli [a women's collective], I found a group of people to talk to about feminism across generations. I started spending more time there than anywhere else.

When I first came to Delhi, I was very uninspired by college, so I went looking for groups to join. I really liked the way that Nigah [a queer collective] was structured. Participation was voluntary, and the people didn't take themselves too seriously. Many conversations happened there because it was unstructured. At that point, it really saved my life in Delhi.

I think in colleges it's getting much easier now. There are more queer collectives on campuses and a lot more spaces to find other gay people to speak to.* ∎

* The years since the earliest public demonstrations for LGBT rights in Delhi (1990s) have seen the growth of classroom discussions and the mushrooming of support groups on campus.

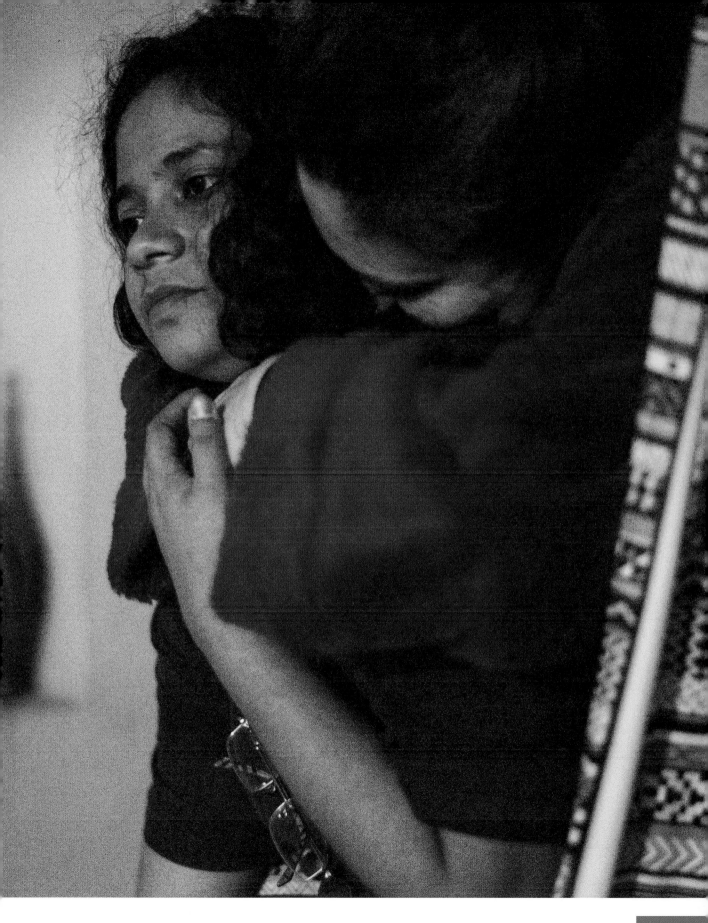

Sonal is a young researcher and writer who writes about domestic workers and labor rights. He lives with his family in the "servant's quarters" at the hospital where his mother is employed. He has completed his master's degree and speaks fluent English—an important skill in India today that brings him into contact with middle-class society, where he can be more open about being gay.

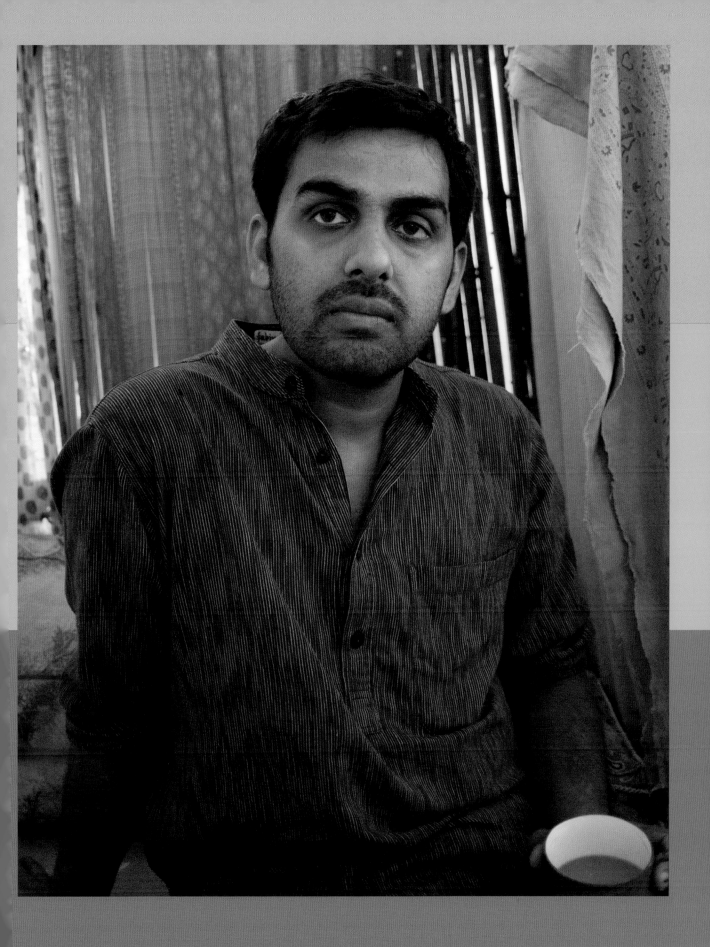

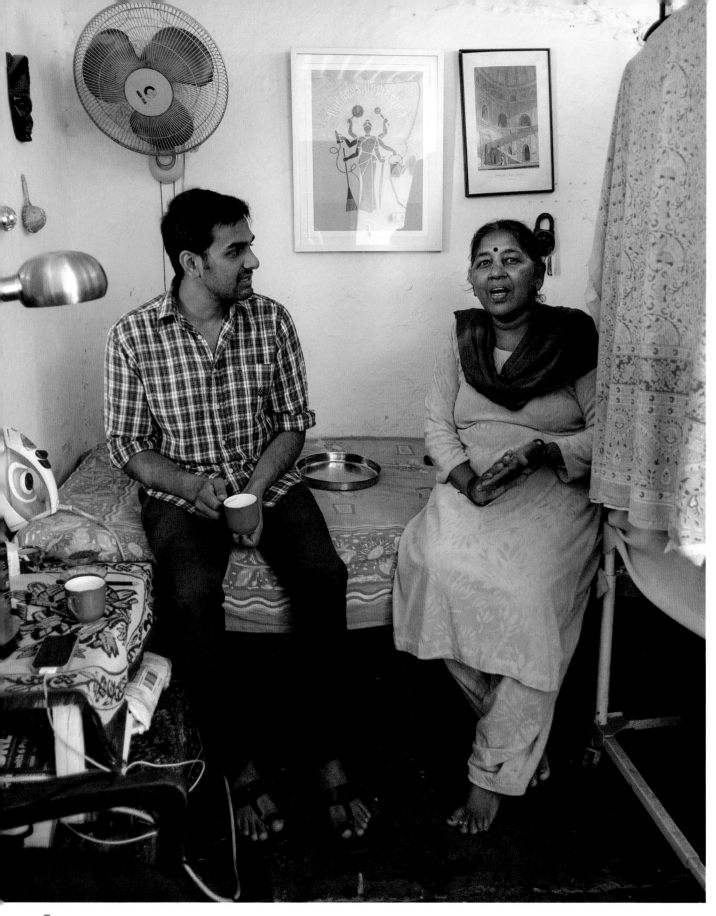

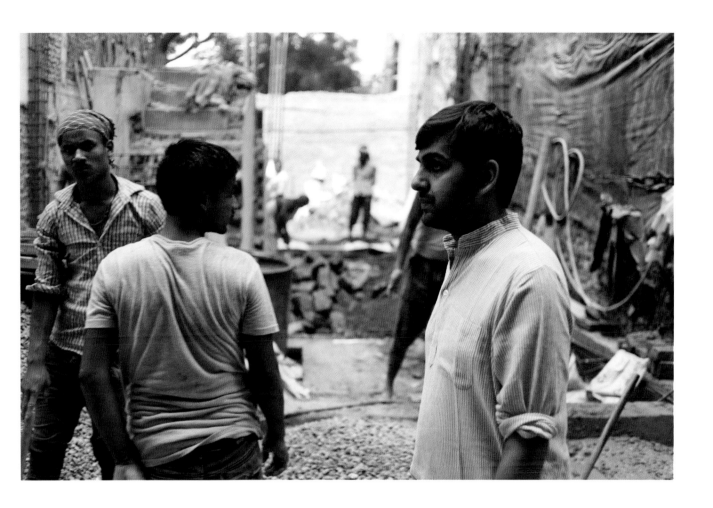

I work as a researcher on urban issues broadly looking at labor and gender. I am the eldest son in the family and I have two younger brothers. We live together. I was sexually active from when I was thirteen. I was exploring sex, within my school, with my cousins, and with boys in the neighborhood, and it was mostly pleasurable.

When I was growing up, I always dressed up and danced. I enjoyed it and so did others in the family. But when I was around the age of twelve, people at school and in the neighborhood really started teasing me and started cracking jokes at me. They used to harass me for being effeminate.

Then I went online, which made me realize why I was different and what I felt was called homosexuality, and how I could find other people. So first I started with classifieds on the Internet. I didn't find dating sites, but the classifieds where I used to go were "men looking for men." Initially, I was really scared. What if someone blackmails me? So that fear came from what if one person tells another, and it goes to your friends, then finally to your parents. »

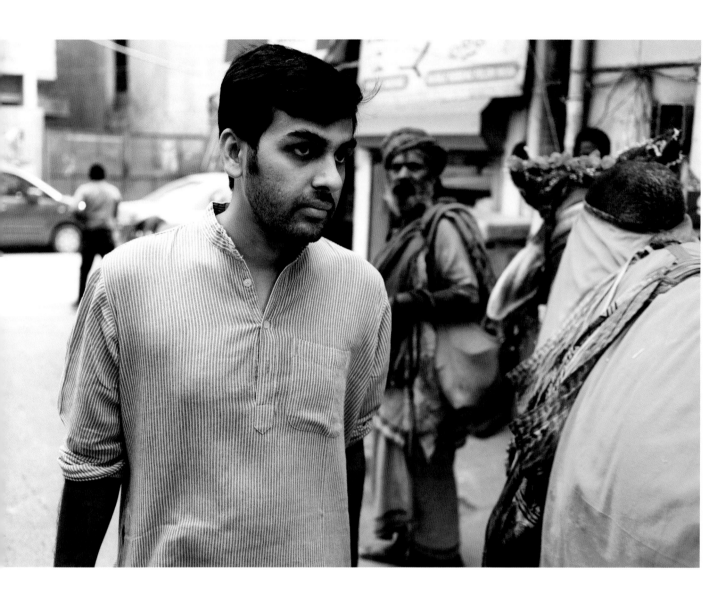

The gay scene is quite amazing at the moment. I meet people online. I am really scared of cruising in parks. I never did. Other than online, people meet at house parties, commercial gay parties, at Pride. Increasingly, there are queer events. We live in a city where the majority of people are scared of the police, who can always harass you. I usually go with people I feel safe with to parties. You never know. What if they raid a party?

I heard about Section 377 in my college. It was 2007 or 2008. Then the High Court judgment came out. I was very excited. For a moment I felt that my country had become progressive. So after 2009, I started gradually coming out to people. After the 2009 High Court judgment there were many repercussions. More gay people began to come out. More parties happened. People started fearing that "Gay people are everywhere. What to do?" So some kind of backlash was inevitable. »

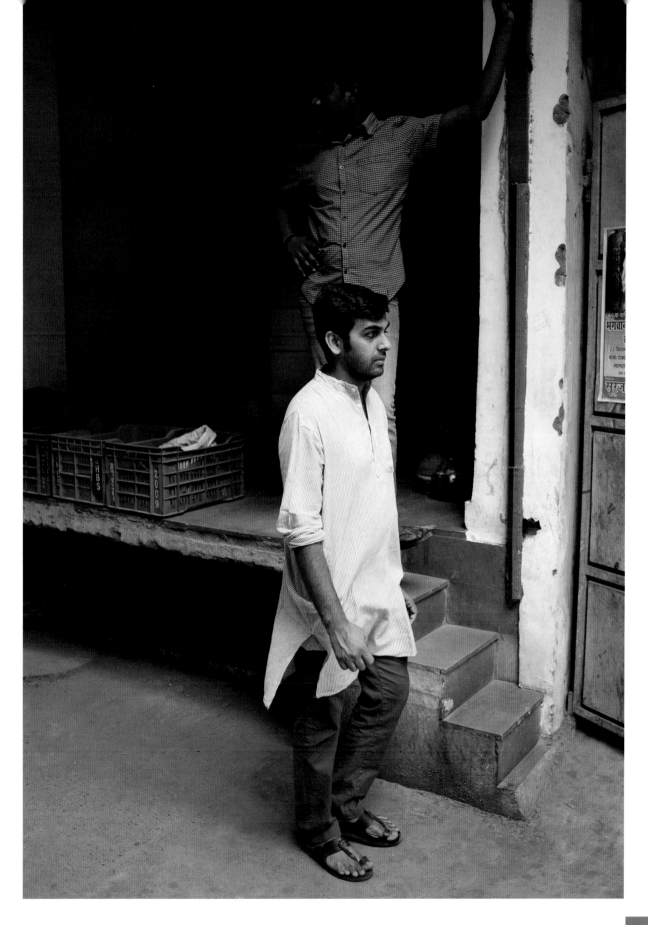

Right after the Supreme Court judgment came out, I was not able to meet boys and hook up for a very long time, even in private places. Even though it was illegal before the 2009 judgment, too, but then the fear wasn't like this. I think now it is different. I didn't know it was illegal before that. You have to know something to be afraid of it. If you don't know you are vulnerable, you don't have fear.

I don't know if the law is a first step, but, yes, it is an important step toward. The law has a responsibility to protect all citizens. ■

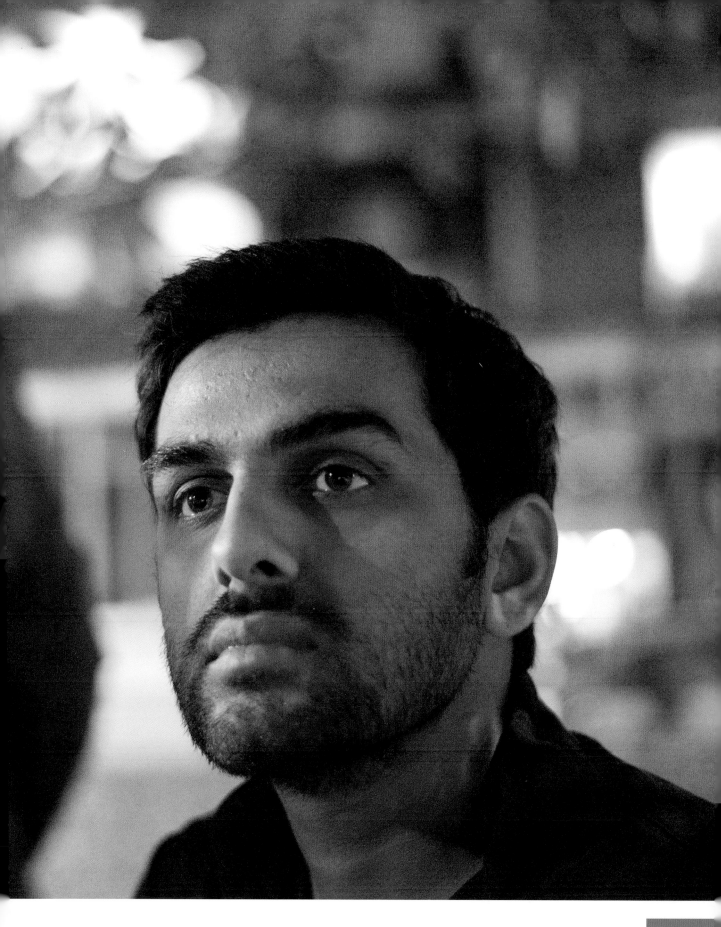

Zahid and **Ranjan** are among the few openly gay couples in Delhi and have been featured in the local media. Ranjan, who is an upper-caste Brahmin, is Kashmiri and has lived and worked in Europe. Zahid, who is Muslim, was born in Jeddah but trained as a doctor in India. Both now work in the Delhi office of Médecins Sans Frontières, where they are open about their relationship.

ranjan
&zahid

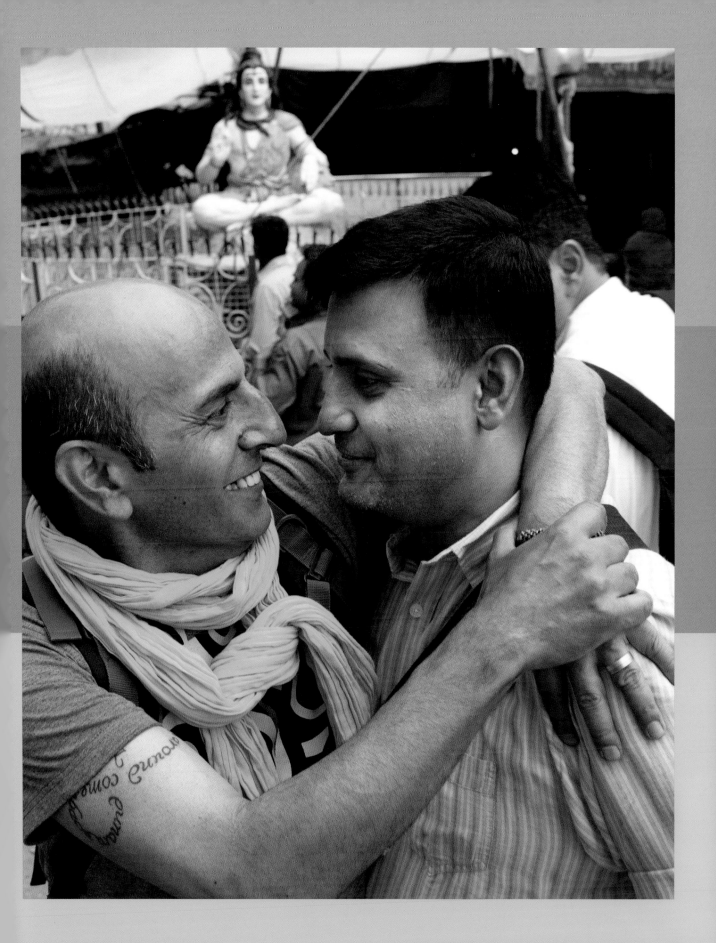

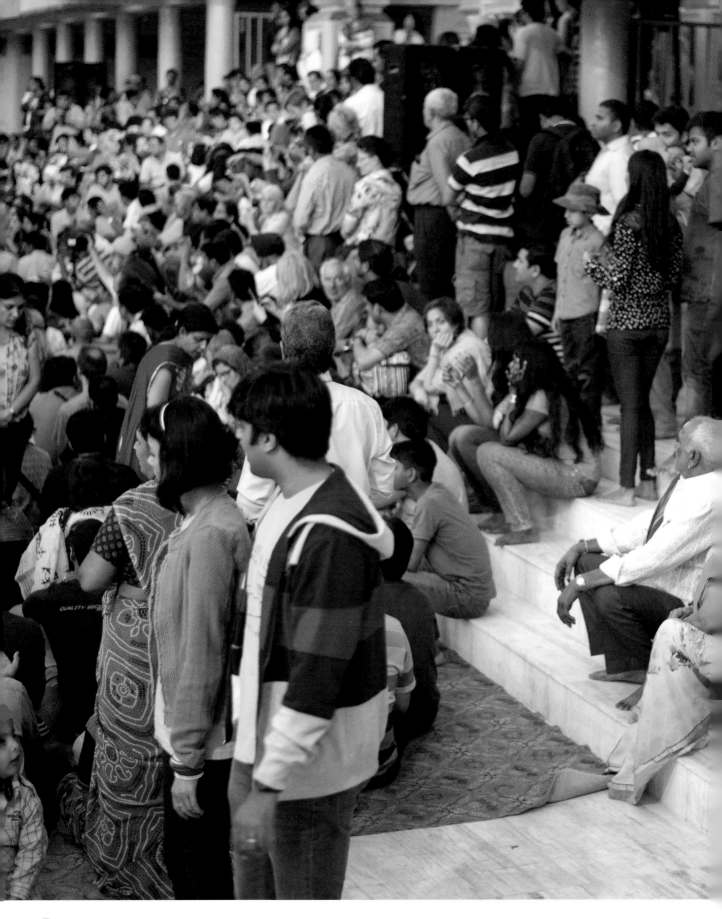

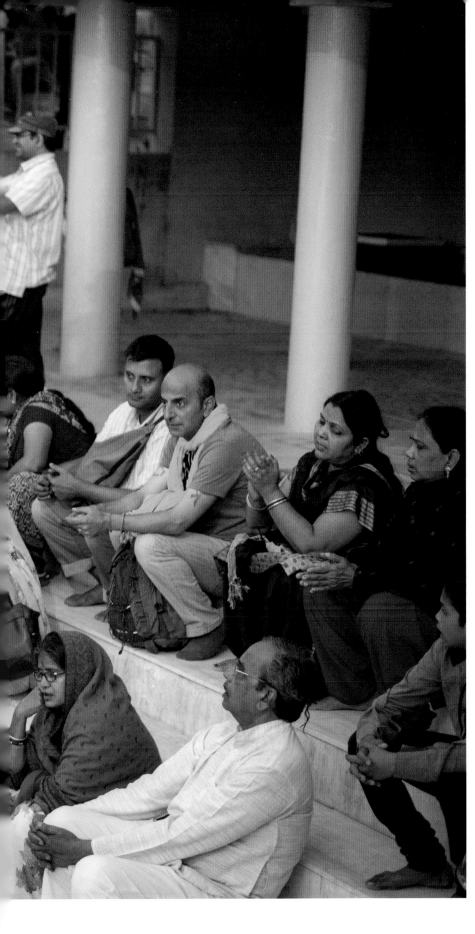

Zahid: In 2003, I came to India from Saudi Arabia. I'm a medical doctor. I work with Doctors Without Borders (MSF).

Ranjan: I'm from Kashmir and live in Delhi now. Zahid and I have been together for ten years. »

Zahid: He's my boss.

Ranjan: But only for a short time.

Zahid: When I joined the organization, I asked them at my interview if they had any issues with my being gay, and they said no. They did not discriminate, unlike the previous place where anybody could walk up to me and get angry: "How could you be gay and Muslim?"

Ranjan: Since 2000, I've been working here in India. I've made it very clear at my interviews that I'm gay and it's never been a problem. Meanwhile, when he applied to MSF and I was already there, it felt good that the organization acknowledged the relationship. A lot of others don't have that because such relationships would not be acknowledged because of the law. But our insurance is covered by an Indian medical insurance company and so they won't let me be a dependent on his medical policy. »

Zahid: I opened a profile on a gay dating site. We met online and that's how our relationship started. He was a nice person. He was cute. I never felt anxious about being online in India. I had been anxious in Saudi Arabia. All my anxieties were there. I was always with my family in Saudi Arabia. But not here. I wasn't worried about being on the Internet.

Ranjan: Even for me the Internet was very new. I didn't even have my own computer then. It was probably a cyber café. I was not feeling anxious about meeting him because he had put his picture up. By day three we knew we were serious.

Zahid: [*laughing*] It happens very quickly. My real anxiety was to look good in the pictures, not that I would be entrapped. I grew up in Saudi Arabia, so I had been confronting the situation of my sexuality being illegal for years. I knew there might be consequences. »

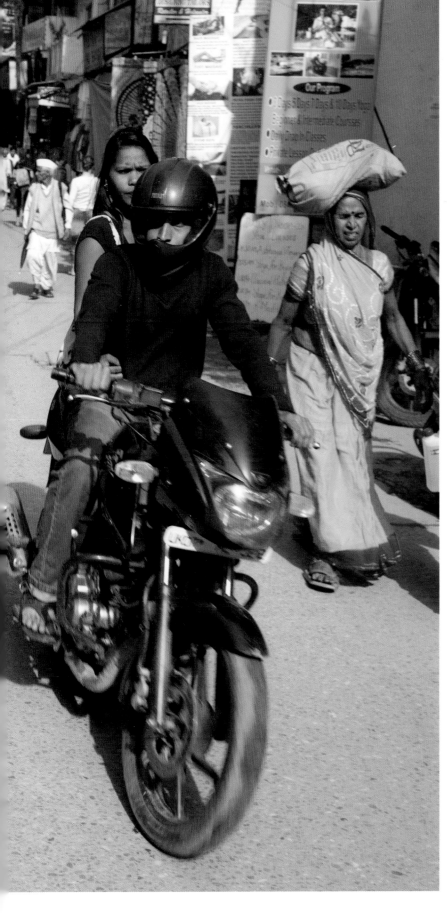

Ranjan: Even though people are more out today, there is that thing in the back of the mind saying this is still illegal in this country and tomorrow if they decide to crack down on it, we are too exposed already, so we would be in a lot of trouble. He was living with his family and I had an apartment, so he moved in with me and we lived together for a while. We live here in my name, or we live in his house, which is in his name. Up to now it hasn't been important. If there is a medical emergency, I'm not sure. . . . I have a will, and he should too. For my will I have spoken to a lawyer about what I want. But he said that the family can contest it.

Zahid: Till now, I hadn't thought about it at all. These things never came to my mind at all.

Ranjan: Maybe because we know that we each have our own home.

Zahid: We spend time with my brothers' kids. We live with them in my house.

Ranjan: My immediate family gives him the respect he deserves.

Zahid: I went to work in Chhattisgarh, an isolated part of India, and the team asked me how my partner was, which was very nice. These are local people. We don't have much in common with my own relatives. Some of them I don't speak to. They are very religious. I tell my family if you talk to me, then talk honestly about me.

Ranjan: Our world is very limited. There is work, which is very comfortable. There are our close friends, who are very comfortable, and then there are our immediate families, who are very comfortable. So in a sense we are operating in a very private sphere. ■

Chapal is an openly gay man living in Delhi with his mother, grandmother, and brother. He grew up in nearby Agra and went to university in Delhi and New York. He was part of a gay male support/activist network in the late 1990s that was linked to a local HIV/AIDS clinic. Now in his thirties, he makes his living as a freelance writer on issues of public health.

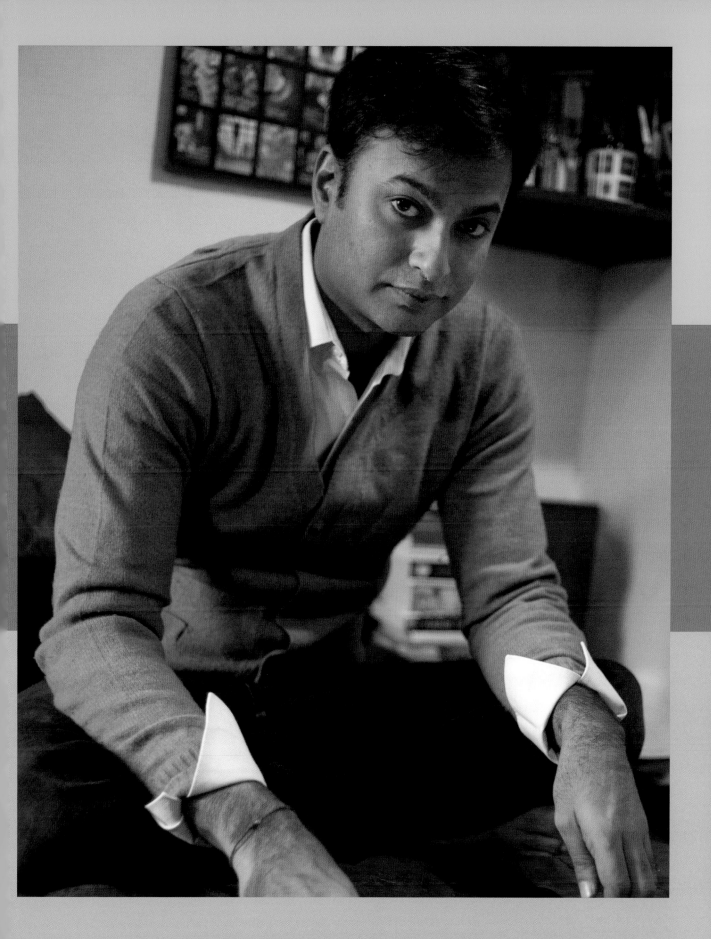

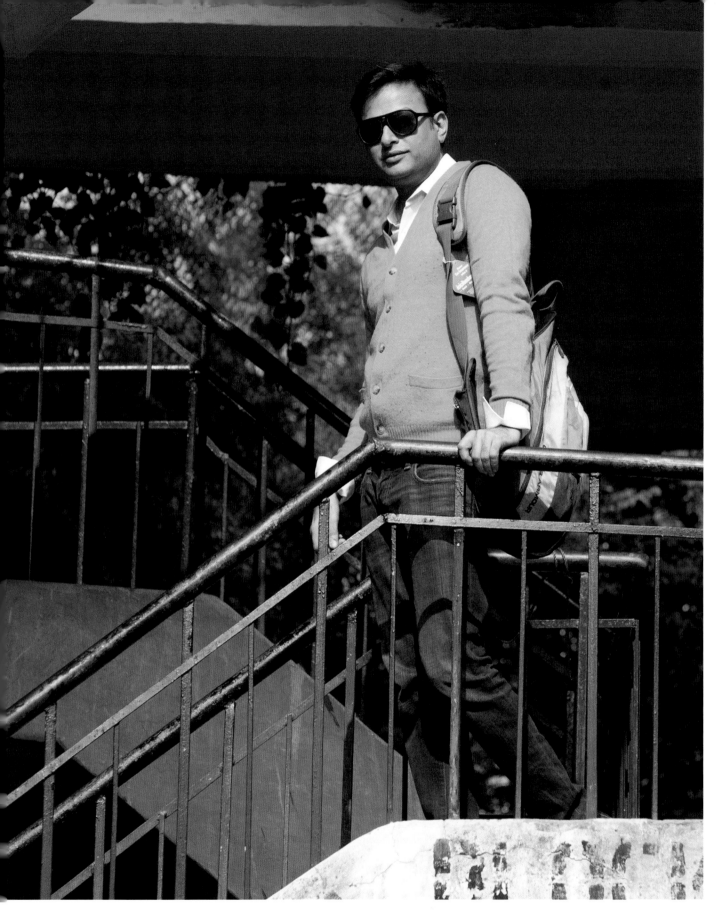

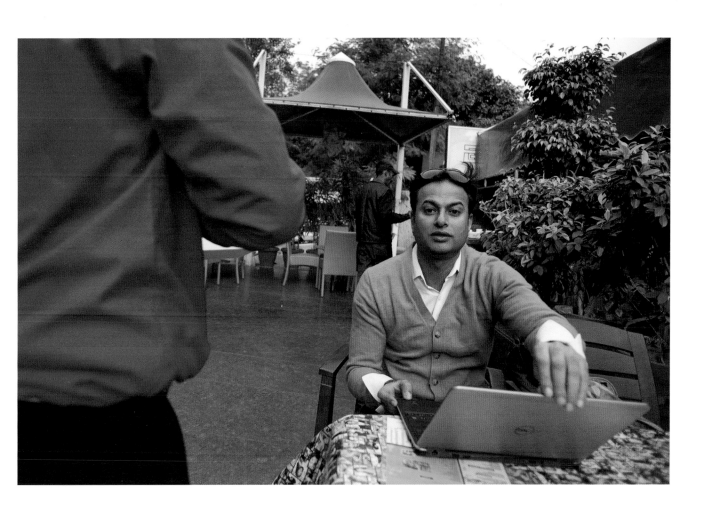

I grew up in Agra and then lived in Delhi. I went to college here and in New York. I had a very large family. It had everything to do with my development. I had a lot of sex with my cousins, between men, but they were all straight on the surface and no one spoke about it. It was something that you grew out of.

I've been an out gay man since I was nineteen. I came out to myself at twelve or thirteen. I knew the words for [being gay], but there was no information, only books and school friends experimenting with masturbation. We were all having sex with each other but the word "homosexual" was never mentioned. Then there was a separate life where I played with a lot of kids in my neighborhood who were not as affluent, and they had a name for it. But for them as well it was not about being a homosexual. It was more about just sex. »

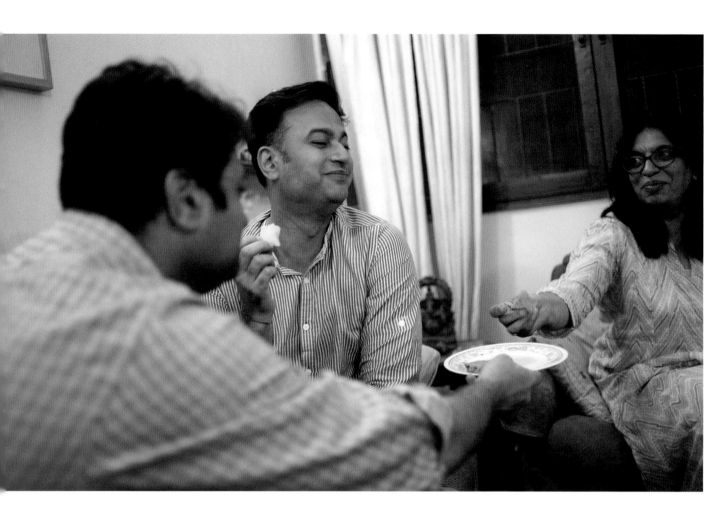

When I moved to Delhi, there were no groups in the university or outside the university. I was referred to a gay support group [Humrahi]. Some of the gay men introduced me to the party scene, which was very wild. This was primarily an English-speaking group. The group talked about issues like penetration. I didn't realize that people could discuss issues like this. There were discussions about rights and the law, and it was almost universally believed that this law [Section 377] can only be overturned through educating people about HIV. But the rights narrative was very skewed. We weren't empowered enough to think that we would get our rights in our lifetime.

There were people who led an active gay life and who got married [to women] and kept the gay life outside marriage. They didn't see the rights issue as their issue at all. There was also a whole set of educated guys who ran off to the West. A smaller group felt there should be an agitation and that you should write about it in newspapers. I think the turning point was the sensationalized murder of a gay man in 2004.** After this there was a backlash [against homophobia] that helped foster the rights movement.

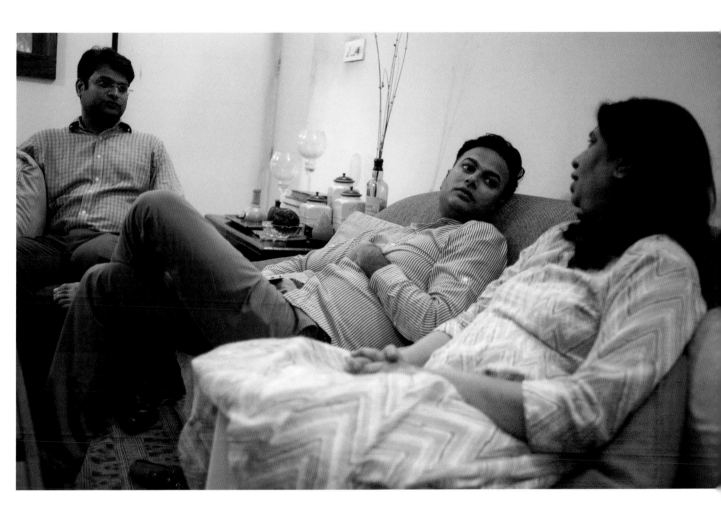

My lifestyle has changed. There appears to be more social acceptance. Therefore, I am more out. But it has shrunk my dating life, and a lot of people at work or in the professional mainstream don't stop discriminating against you. Although I'm not anxious, I don't think being gay is not a problem. For example, I know of two people who committed suicide. We don't have support and counseling in place. For some people the reinstatement of this law has been a death knell.

The law even when it was struck down just decriminalized us. It didn't give us rights. We cannot adopt. We cannot get married. Nobody wants a gay tenant. It's hard to get a roommate. In my gym 80 percent of the people know about me, and half of them smirk when I go in there, but it doesn't deter me. I would love to have a partner. I've been in two long-term relationships and they've been extremely fulfilling.

** Pushkin Chandra, a United States Agency for International Development (USAID) officer, and a male friend were murdered at Chandra's home in an upscale locality in Delhi. The media used the murder as an occasion to "out" Delhi's gay subculture in the most vitriolic homophobic terms possible in a "blame-the-victims" culture. Chandra's father spoke out on his son's behalf, which slowly turned the media toward a more sympathetic stance, a position the English-language media has generally upheld since then.

Anita is one of India's leading contemporary artists. She came to Delhi from Lucknow as an undergraduate. At college she fell in love with a woman. The relationship didn't end happily, and since then she has had a series of unfulfilling relationships with women who were married to men and unlikely to leave their husbands. At one point, she was married to a man. Now in her fifties, she is still looking for a same-sex partner. She is open about her sexuality at work and in public and can be frequently seen at protests and marches.

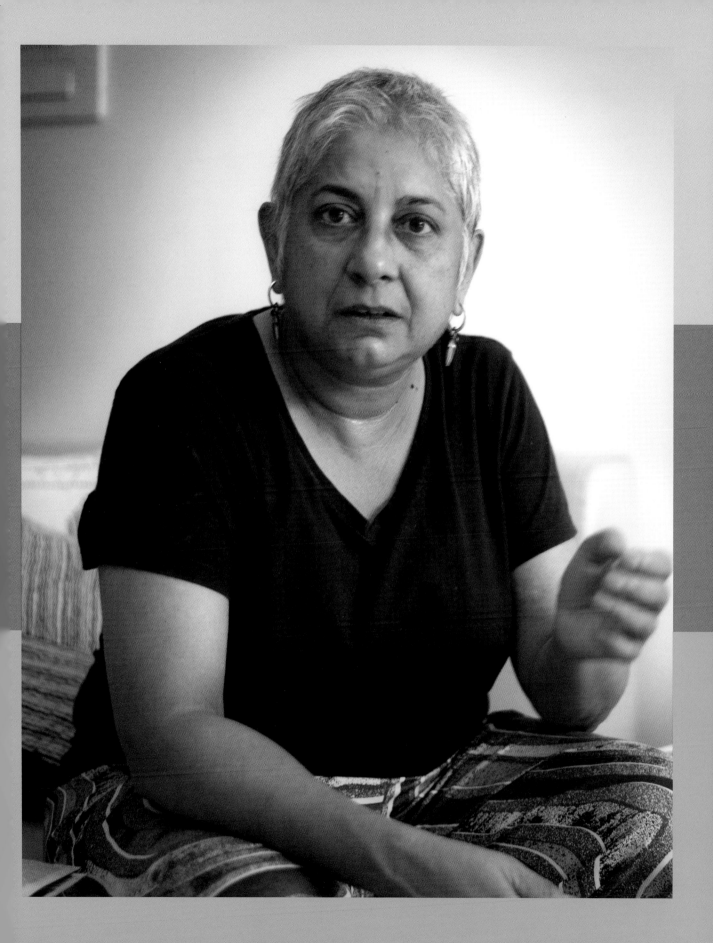

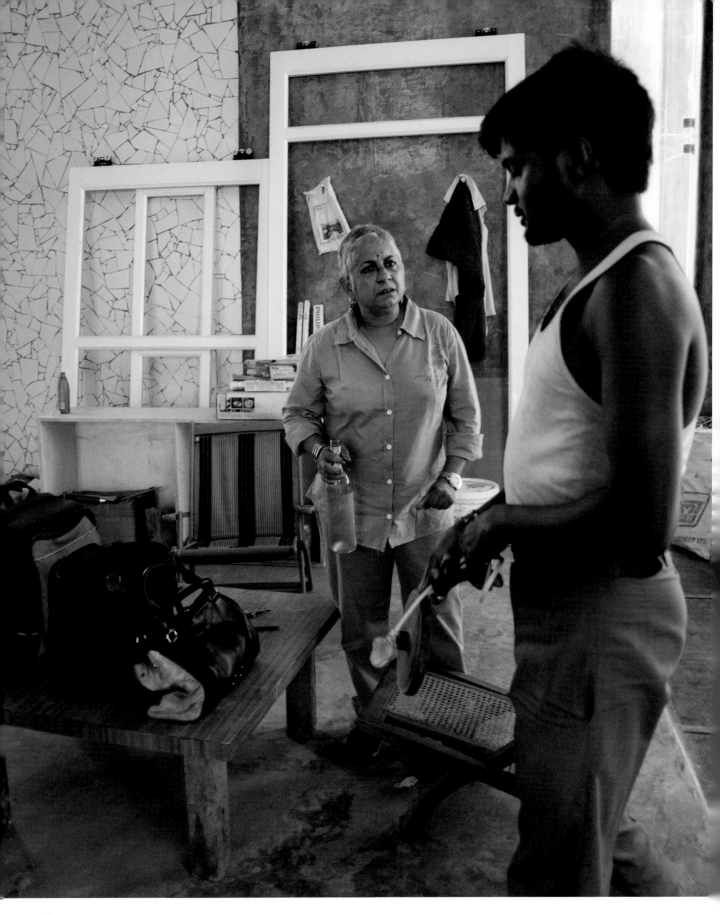

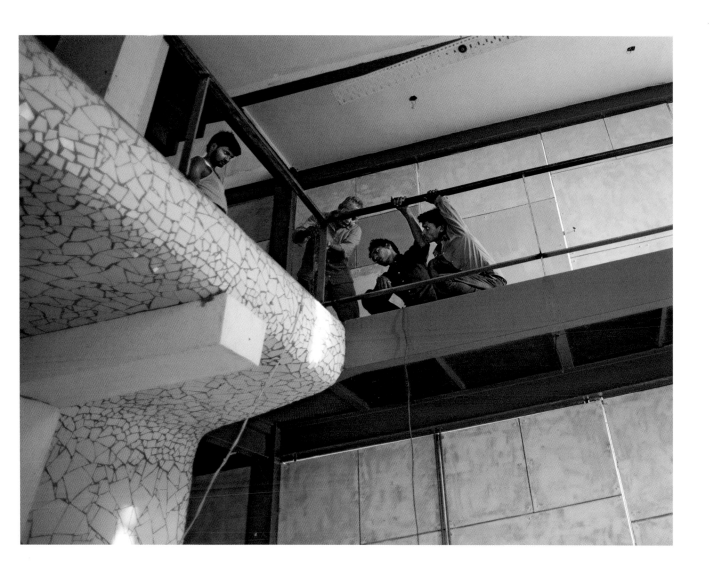

I lived and studied in Lucknow [in Uttar Pradesh] in a conservative Hindu family. I went to college in Delhi between 1975 and 1979. One of my classmates became a friend. Then it hit me, this physical craving for the girl. We became lovers in our third year. It was on and off. She felt very guilty about it, and it was a secret. I had no guilt. I didn't know about lesbians or about LGBT. I had no clue. Then I went away to study art history and we split up. At one point it became so painful I retreated into the most depressive moment in my life. »

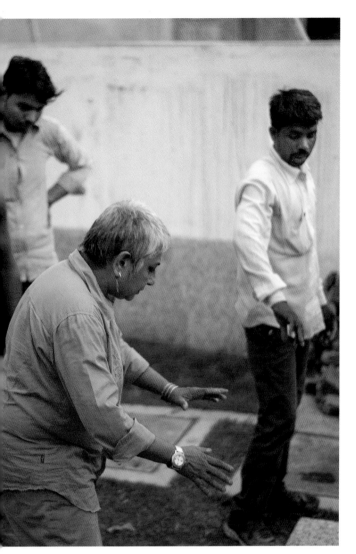
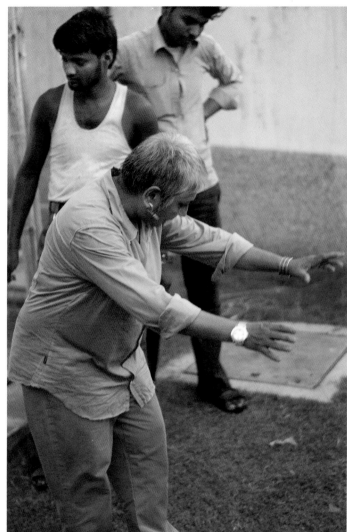

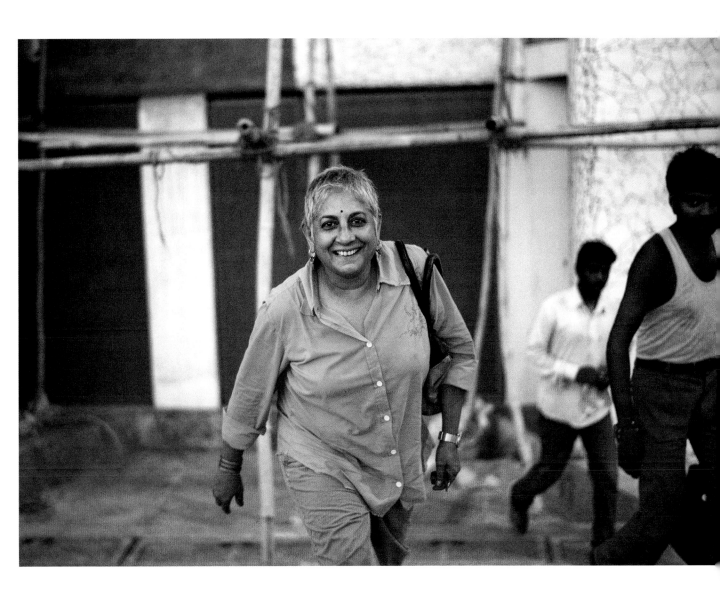

As far as the law goes, that never deterred me. My problem has been to not be able to have a long relationship the way I want it—to live together with another woman. I've not been able to achieve that and I'm fifty-six years old. There are so many reasons that a change in the legal system would make it easier to find someone. For twenty years I've lived alone. That's a lot of time. When you are older, you meet a lot of younger people. Their priorities and what they want from life and a relationship is not what you want from the relationship.

Art and the building I am constructing occupy a lot of my mind space. I'm healthy. I always have love interests. They're married. I'm there; they realize then that there are parts of their lives they haven't explored. ▪

Saleem is from a well-known Muslim family in Lucknow. Now in his sixties, he is retired and has returned to his hometown after a career teaching history at the University of Delhi. He has identified as gay since the 1970s and is open about his sexuality to his family and in his academic work. He co-edited one of India's first examinations of same-sex love in an effort to prove that homosexuality has roots in the subcontinent and is not a foreign import as some conservatives have claimed.

saleem

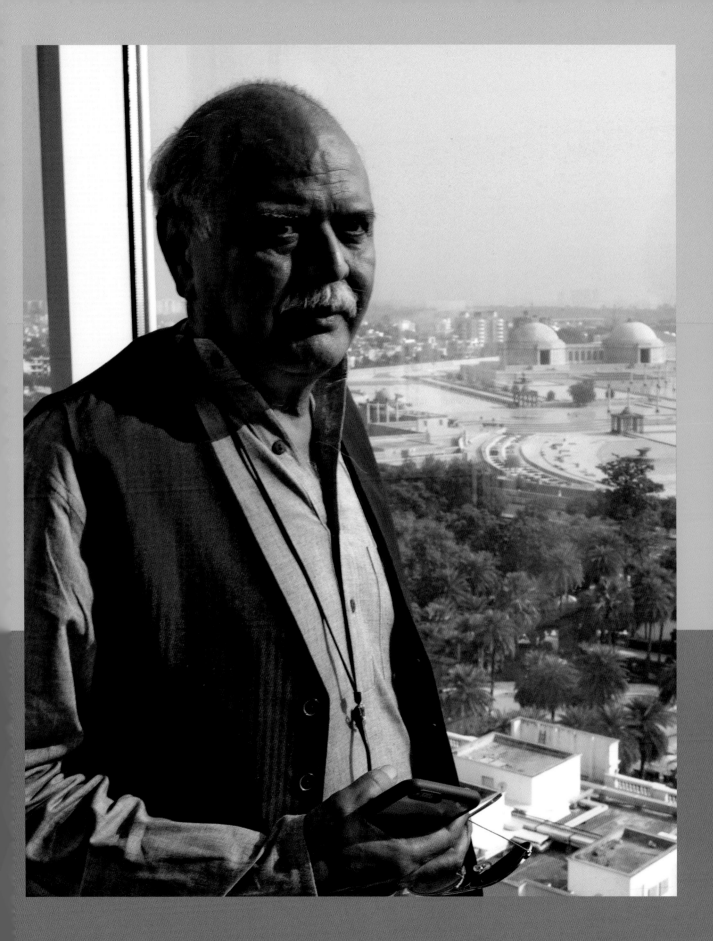

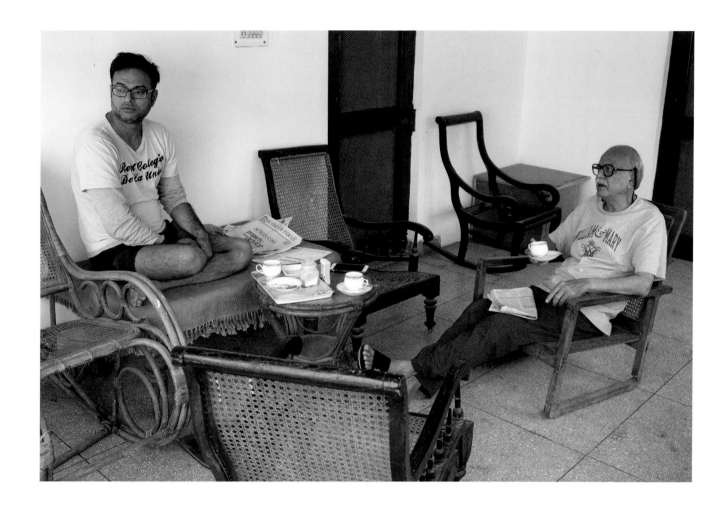

Coming back to Lucknow [from Delhi] was one of the most sensible things I did. I think I am in a much better place now than I've ever been in my life. I can be independent if I want or have family. I'm happy to be grey and gay. There are advantages to being older. Aside from health issues, I'm happier being a gay man now in my sixties than I was in my twenties and thirties. I'm glad not to be young in this day and age. I don't mind that I've ended up alone. I'm single but not lonely. There are advantages to being alone and single at my age, although I wouldn't be saying that if I didn't have family and friends. »

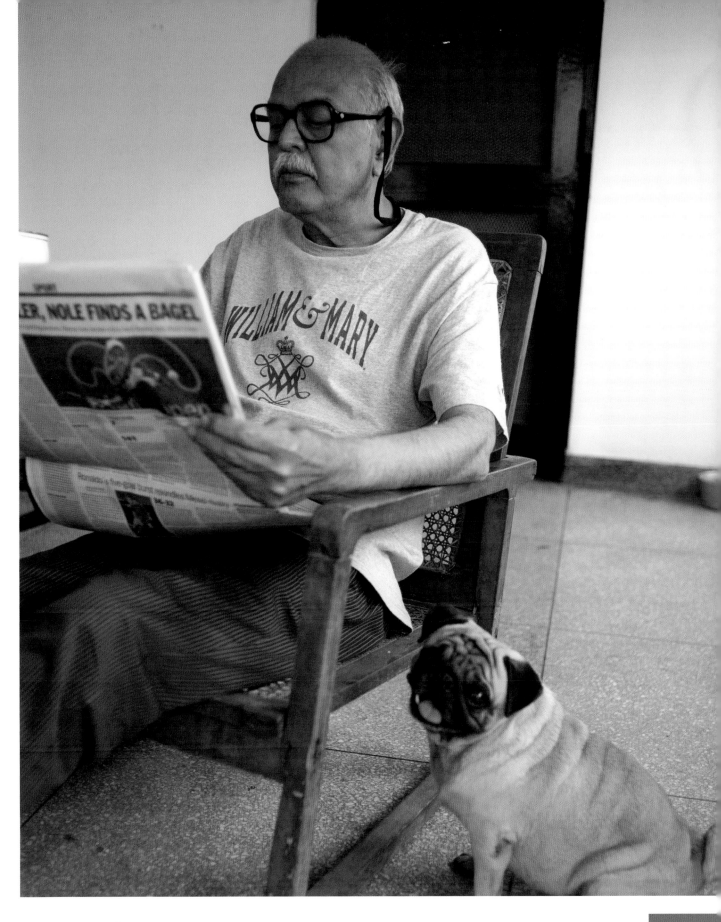

The interesting thing is that the problems are of such a personal nature. The struggles were all within. One realized the importance of the law after hearing what the law was doing to other people, hearing their life stories, and their problems with the law. You saw the fear. You saw the public spaces, the cruising, the harassment, and the cops. It was all about disclosure and the fear of family, friends finding out, and people at work finding out. It came to me in a social situation not in a legal situation, that a friend of a friend might say something, the worry about dismissal, the social stigma. This was when I was a student in the early 1970s. My circle of gay people was so small it was entirely limited to personal encounters. There was no gay social space. It happened in any public space, whether it was a bus, cinema, or park. »

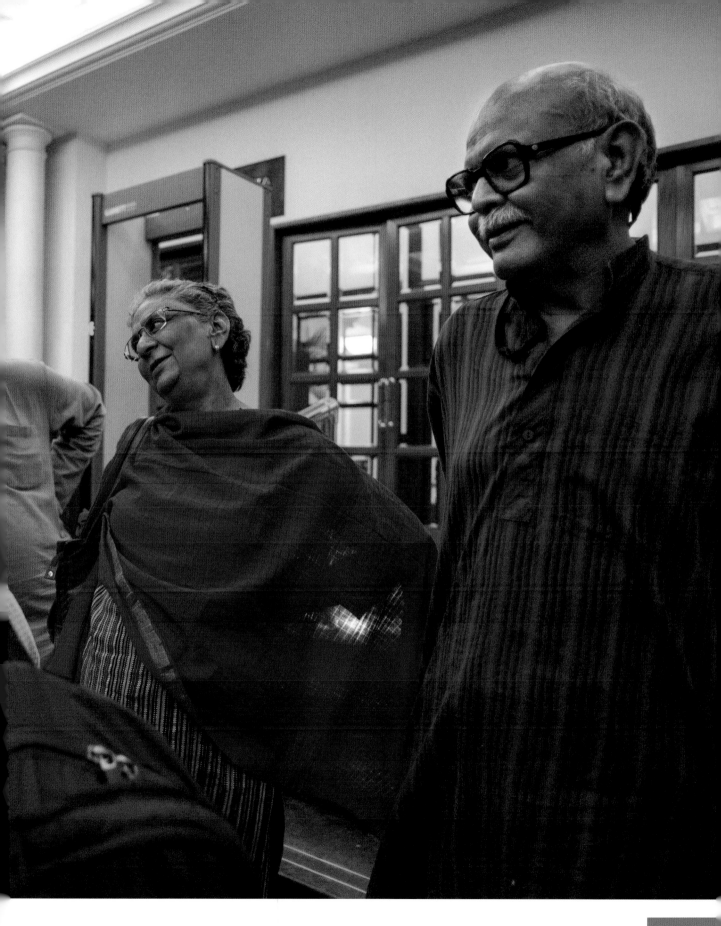

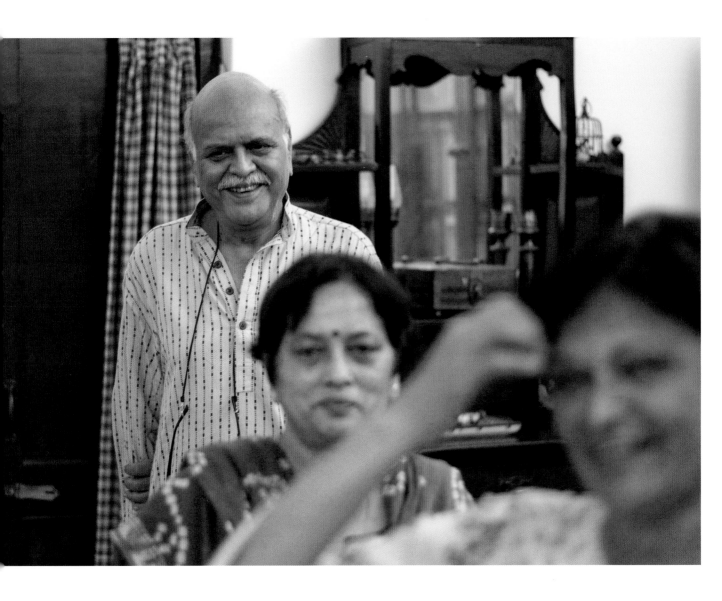

Then I went away to Canada till the early 1980s, and I made gay friends, saw a gay lifestyle evolve. However, the bar raid I was caught up in brought home the power of the law. I came back with ideas of a gay community in Delhi.

The 1980s were very crucial for community building and forging a gay identity. Cautious but yet more empowered as there were gay people in the network who could help—doctors, lawyers, counselors. It was more than social. That's what provoked my research into the book. There were certain intellectual questions that were always met with silence. The fact that everyone knows those arguments now was worth it.

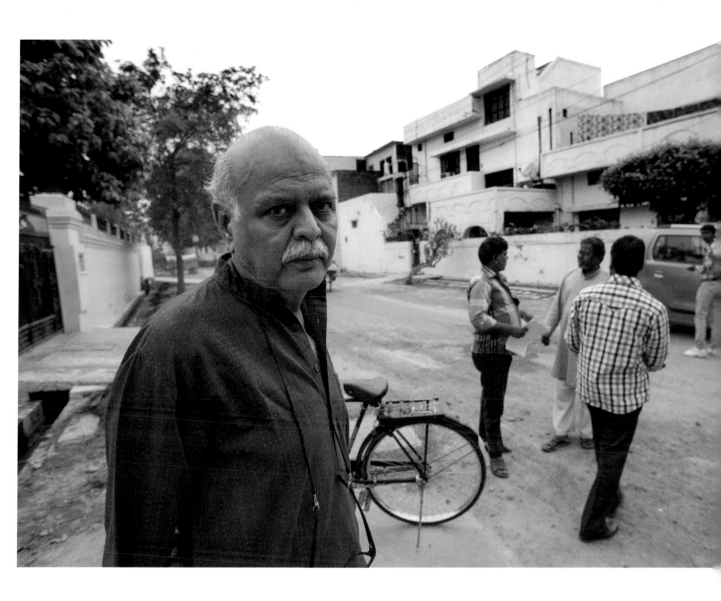

Since the Supreme Court judgment, the struggle is going to be far tougher that it had been. I think homophobia like the Supreme Court judgment is going to be much more open. It affects me personally because I have invested so much into it as a cause, as something I believe in, something that I have committed myself to. It is very important to me. If they ban this book, that would be a very big issue for me, like being silenced. This book has given me a certain credibility even with homophobes.

Meanwhile, social change is in our favor while the law is against us. We have a lot of sympathy. Alliance building with other minority groups on the basis of human rights is the way to go. This government won't change the law. There has never been a right-wing government that supported human rights. Unofficial homophobia is on the rise. This government is not going to act against it. ◼

Acknowledgments

We would like to dedicate this book to the memory of Charan's mother, Bhagwati Devi, who died 27th October 2014 while he was working on this project.

We would also like to dedicate this book to all those people in Delhi and India who did not survive their struggle with HIV/AIDS. Some of the individuals we knew personally: Vijay, Manjeet, Pappu, Lata, Parveen, Rajni, and Anish.

We would like to thank Gautam Bhan for introducing us to EWS for this book project.

Our heartfelt thanks goes to those who have participated in the book; without their unconditional support and their absolute trust in us, this project would not have been completed: Jatin, Deepti, Geeta and Kath, Anita, Lily, Gautam, Rahul, Ranjan and Zahid, Kishan, Ponni and Indu, Saleem, Pavitr, Chapal, Rizwan, Akshara, Rituparna and Sonal. A special thanks to Jatin who introduced us to some of the people who appear in the book.

We would like to extend our gratitude to Radhika Singh, Anita Dube, Ranjan Koul, and Deepti Sharma who had generously let us stay in their homes—while we were visiting New Delhi—during the course of this project. Especially to Victoria, Ganga, and Rajni who lovingly made delicious food during our time there.

We would like to thank Nigah—a queer collective that we are part of and where a lot of conversations have taken place, as well as many other homes and places where critical queer discourses flourish in New Delhi.

A sincere thanks goes to the creative team at EWS, especially Jurek Wajdowicz, Lisa LaRochelle, Manuel Mendez, Yoko Yoshida-Carrera, and Emma Zakarevicius for keeping us on our toes.

Last, but not least, Babe, our seventeen-year-old Shih Tzu, who gave us unconditional love and made us feel rejuvenated when we were in London with her. We are grateful to Shalini, Ambika, Monika, and Rudi who looked after her while we both were away. Babe died on 22nd July 2016.

The photographs presented in this book were made possible by a commission from Jon Stryker: philanthropist, architect, and photography devotee.

This book was made possible in part by a grant from the arcus*
FOUNDATION

*The Arcus Foundation is a global foundation dedicated to the idea that people can live in harmony with one another and the natural world. The foundation works to advance respect for diversity among peoples and in nature (www.ArcusFoundation.org).